Nikon
SB-25

Laterna magica

Magic Lantern Guide to
Nikon SB-25 Flash System

A Laterna magica® book

First English Language Edition July, 1993
Published in the United States of America by

**The Saunders Group
21 Jet View Drive
Rochester, NY 14624**

From the original German edition by Michael Huber
Translated by Phyllis M. Riefler-Bonham
Production Editor, Marti Saltzman
*With special thanks and appreciation to those
behind the scenes who made the publication
of this book possible.*

Printed in Germany by Kösel GmbH, Kempten

ISBN 1-883403-02-2

® Laterna magica is a registered trademark of
Verlag Laterna magica Joachim F. Richter, Munich, Germany
under license to The Saunders Group, Rochester, NY U.S.A.

Contents

These photos demonstrate the importance of choosing the correct exposure method and the appropriate flash mode. They were photographed using the following techniques:

A) Light measurement with hand-held exposure meter (1 sec. at f/5.6) without flash.
B) Matrix-balanced flash (1/125 sec. at f/4).
C) Center-weighted flash (1/125 sec. at f/5.6).
D) Fully manual flash (1/125 sec. at f/11).

The need for the photographer to be well-versed in different flash techniques is clearly illustrated by the varying quality of these end-results. This manual is designed to help you get the best possible pictures using the many capabilities of the SB-25 Flash System.

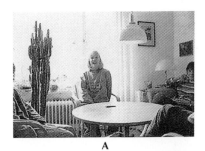

A

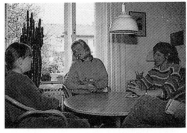

B

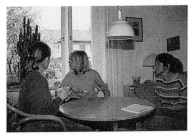

C

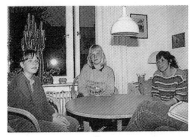

D

About This Manual

How this Manual was Conceived

This book is intended as an expanded instruction guide to the Nikon SB-25 Flash System. In writing it, the author consulted both amateur and professional photographers. The many experiences they have shared, along with many illustrative examples, have contributed to this book.

Understanding the Basic Principles of Flash

The final chapter in this book is a general explanation of the principles of electronic flash along with descriptions of various exposure options and techniques. It also explains many of the terms used throughout this book. If you are unfamiliar with any of these, I suggest that you begin by reading the chapter "The Basics of Flash Technology" as it will contribute greatly to your understanding of the rest of this book.

For Whom this Manual was Written

While discussing this topic with amateur and professional photographers it became obvious that most people take advantage of only a fraction of the capabilities of modern microprocessor-controlled camera systems. This is even more true when using flash. The combination of different TTL autoflash options with various exposure methods (ranging from manual to the many automatic program modes) and different exposure-metering preferences (ranging from spot, to center-weighted, to matrix metering) poses a puzzle for the photographer using even the SB-24 flash. A comparison of the functions of the SB-24 with the expanded SB-25 doesn't make matters easier. Ultimately, the photographer will often settle in on one "tried-and-true" method, leaving all of the many remaining options offered by his camera/flash combination unused.

This manual is intended for those who want to better understand the many innovative capabilities of the SB-25 so that they can use its many features to best advantage.

An "Improved" Instruction Guide

In order to make optimum use of the SB-25, one should possess a background knowledge of flash technology. However, due to a reliance on today's sophisticated, automatic gadgetry, this knowledge is frequently fraught with gaps. Therefore, this manual includes a concise introduction to the fundamentals of flash technology and to that extent, goes far beyond a conventional instruction manual. It concentrates mainly on the use of the SB-25 in conjunction with the N8008s/F 801s, N90/F90 and F4 cameras. With the N5005/F-401x or N6006/F-601 camera, most of the benefits gained from using the SB-25 will be covered generally. The use of the SB-25 with the N90/F90 is covered specifically as this combination represents the maximum capabilities of the SB-25 or highest degree of sophistication in automatic flash performance.

Also, as far as detailed procedures such as "First you push this button and then that button," this manual will be intentionally brief. Otherwise all of the many minor differences among various camera models would have to be addressed, making this manual cumbersome and confusing to the user. Therefore, this manual will explain only related and optional applications. The specific "step-by-step" procedures include instructions which apply to practically any SB-25 and camera combination for each flash method. Additional details can be found in the SB-25 instruction manual which you should read completely.

For additional information regarding specific Nikon cameras and accessories, I will refer the reader to the camera manuals which are published by this company and are available for practically every current Nikon SLR camera. Detailed information regarding accessories can also be found in my "Nikon Systems Book" which will be published in the near future.

Focusing with the AF-Illuminator: This night-flowering cereus was focused on by using the AF-Illuminator in complete darkness; then the exposure was made with flash.

Organization of This Manual

One shortcoming of many instruction manuals is the organization which often emphasizes technical functions and different models instead of applications. Frequently, the user cannot see the "forest for the trees." Therefore, this manual is organized so that you will first be introduced to the technology and the operating elements of the SB-25. Subsequent chapters will then deal with "where and how is it used?" Following this are chapters dealing with how particular photographic situations and creative techniques can best be handled with the SB-25 flash. Another chapter features the use of the flash in specific photographic applications. The last chapter offers a systematic introduction to the fundamentals of flash technology.

Important Notes

Camera Names and Models
From this point on, different versions of the same basic camera model are explicitly mentioned only if they are of significance. If "N8008/F-801" is mentioned, for example, this would also include the N8008s/F-801s; if the "N90/F90" is mentioned, this would also apply to the F90S and F90D. (The F90 is marketed as a package with the "S" and "D" model designations in some countries. The only difference is the addition of standard databacks: the MF26 in the case of the F90S, and the MF25 with the F90D. These databacks can also be purchased separately.)

Verification
Due to time and expense constraints it was not possible to verify in detail all the data and information provided by Nikon. Likewise, it was not possible to test all of the functions of the SB-25 with all cameras. (Practical tests of the SB-25 were conducted with the N2000/F-301, N8008/F-801, N8008s/F-801s and N90/F90 cameras. I would welcome suggestions, should you find any inconsistencies.

I hope you enjoy photography with the SB-25 flash system!

SB-25 -
The Best of Flash Technology

Compatibility

Nikon has long been recognized as a company that supports a system approach in its well-thought-out concept of compatibility of equipment. I have found the SB-25 to be no exception to this philosophy, since it can be used with all previously manufactured Nikon SLR cameras. This is a great advantage especially for those photographers like me, who own more than one camera body. Of course, it is not likely that I would buy an SB-25 just for use with my FM-2 camera. However, I would definitely buy one to use with my new N90. I could then use the SB-25, not only with this camera taking advantage of 3D Multi-Sensor TTL autoflash, but also with my Nikon FA using the standard TTL autoflash mode and with the FE or FM-2 camera as a non-TTL automatic flash. Apart from this specific example, the capabilities of the SB-25 can be used to some extent with practically all Nikon SLRs. For example, the built-in AF illuminator assists AF focusing in low light or total darkness with all Nikon AF SLR cameras.

"User-friendliness"

The operating buttons of the SB-25 are rubber-coated for comfort and ease of operation. They are slightly recessed to prevent inadvertent actuation. While the operating logic is not quite as good as that found on most modern cameras, it is fairly well-thought out and many of the main functions can be controlled conveniently by arrow switches. Also, certain functions such as selection of the zoom head setting, and lens aperture can be transferred automatically to the SB-25 from cameras such as the N8008/F-801, F4, and N90/F90. In the case of improper selections, a blinking warning will be displayed. Therefore, little is left for the photographer to forget.

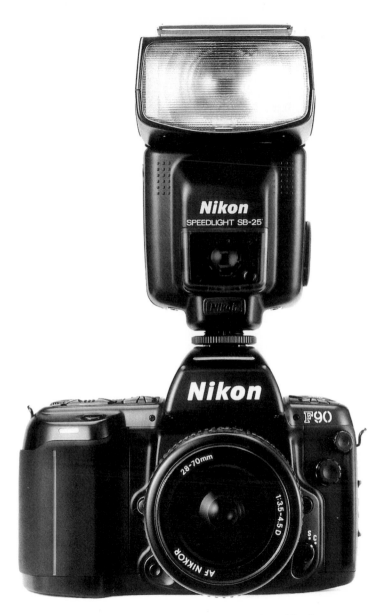

The SB-25 with the N90/F90 camera, a full-featured combination.

Display of Important Data

The SB-25 flash unit has LCDs which indicate selected distances or ranges, as well as apertures which can be adjusted to facilitate the use of manual and automatic flash functions. In addition, the operating status of the SB-25, ranging from the type of automatic flash or special flash functions, to the zoom head setting, is indicated. This display of information is invaluable.

High Guide Number and Seven Performance Settings

With a guide number of 118 (feet) or 36 (meters) at the 35mm zoom head setting or 138 (feet) 42 (m.) at the 50mm setting with ISO 100 film, the SB-25 offers sufficient power reserves for most situations occurring in action flash photography. This high guide number in conjunction with a capacity of up to 100 flashes per set of alkaline manganese batteries shows (considering the relatively compact design of the SB-25) how Nikon engineers have successfully produced energy-efficient electronics. By using manual operation the flash output can be reduced ranging from 1/1 (full) through,1/2, 1/4, 1/8, 1/16, 1/32 to 1/64. As a result, the desired f-stop or distance from the subject (even in the close-up range) can be realized most of the time.

Variable Illumination

The motor-driven zoom head, adjusts automatically for the focal length of the lens when the SB-25 is used with the N8008/F-801, N90/F90, and F4 cameras with 24mm to 85mm AF lenses. An additional built-in diffuser panel for use with a 20mm lens increases the angle of illumination. This exceptional, wide-angle coverage places the SB-25 in a unique position not only in the Nikon program but when compared to other flashes as well. The vertical tilting flash head allows close-ups at -7° and evenly lit bounce flash exposures up to 90°. In addition, the flash head can be pivoted, or swiveled on its horizontal axis by 270°, thus facilitating bounce flash exposures with vertical shots, such as portraits.

Stroboscopic Function

The strobe function can be used with practically all cameras. The calculation of the aperture setting and subject distance in correlation with the flash output has been solved particularly well. Strobe exposures, which, in the past, required considerable experience and many a test shot, can now be taken effortlessly by anyone.

Special Synchronization Options

N90/F90, N8008/F-801, F4, N6006/F601 and N6000/F601M cameras allow optional synchronization with the second (or REAR) shutter curtain. In addition, the N90/F90 offers high-speed synchronization "FP" for shutter speeds up to 1/4000 second.

Red-Eye Reduction and Monitor Preflash

With the flash functions of the N90/F90, the SB-25 has two preflash features. A visible preflash helps reduce red-eye, and an invisible monitor preflash provides information regarding reflectance of the subject.

Low depth of field without background compensation with high-speed ⇨
synchronization "FP": Both pictures were taken at a distance of approximately 4 yards and a focal length of 180mm using an AF-D Zoom Nikkor lens (80-200mm f/2.8 ED). In both cases, the flash exposure was taken at f/2.8 to create the relatively blurred background. The picture at the top was taken with aperture priority; activating a flash synchronization speed of 1/250 second (with 3D-matrix TTL-multisensor, automatic fill-flash using the N90/F90 camera). The background is not only blurred but also relatively light at 1/250 second. The picture at the bottom was taken with high-speed sync "FP" with a manually set shutter speed of 1/2000 second. Considering this example, it could be argued which is the more aesthetically pleasing rendition; however, it cannot be argued that by using "FP," the background is equal to the foreground in brightness.

External Battery Options Available

For those wishing to use an external power source, either the SD-7 or SD-8 battery pack can be connected to the SB-25. These will decrease the flash recycling time to a minimum of 2 seconds and increase the battery capacity to a maximum of 400 flashes.

SB-25 - A Worthwhile Purchase

Those with the N90/F90 camera who want to experience the ultimate in modern flash technology should acquire an SB-25. For owners of the N8008/F-801 and F4 cameras, the SB-25, compared with the old SB-24, may seem a luxury since the only additional feature useful with those cameras is the 20mm wide angle coverage. However, those who require a high-power "intelligent" flash unit today, will probably buy an N90/F90 camera or a future model in this new generation of cameras, tomorrow. Therefore, viewed from this perspective, the state-of-the-art SB-25 is a very worthwhile purchase.

Standard TTL-flash exposures with diffuser: This snapshot was taken with TTL flash control, however, without all the advanced features of modern automatic fill-flash units. The secret of this uniformly illuminated and not "over-flashed" exposure is a special diffuser in front of the flash reflector. This "flash ball" diffuses the flash with a brightness loss of only approximately 1.5 f/stops through a diffusion area of approximately 10 inches. This not only makes the light softer with fewer hard-edged shadows cast by the subject, but the brightness drop in the spatial depth of the close-up range is visibly less drastic.

Overview of Nikon System Flash Units

Model No.	Guide Number† (ft./m)	Focal length	Batteries	Recycling time (sec.)	No. of flashes (approx.)	Built-in AF-Illuminator	Automatic fill-flash	Monitor Preflash+
SB-16B	105/32	28-85mm manual zoom head	4 AA	11	100	No	Yes	No
SB-20	100/30	28-85mm zoom head	4 AA	6	160	Yes	Yes	No
SB-22	83/25	28-35mm diffuser panel	4 AA	4	200	Yes	Yes	No
SB-23	66/20	35mm	4 AA	2	400	Yes	Yes	No
SB-24	138/42	24-85mm motorized zoom head	4 AA	7	100	Yes	Yes	No
SB-25	138/42	24-85mm motorized zoom head, 20mm diffuser panel	4 AA	7	100	Yes	Yes	Yes

† The guide numbers in this overview table relate to ISO 100 and a focal length of 50mm.

* Only in conjunction with N90/F90 or other newer generation cameras.

SB-25 Technology

This chapter gives a brief introduction to the operation of modern flash units. This is followed by an overview of SB-25 technical data. In conjunction with this, particularly important features such as coverage, guide number and zoom head position, etc., will be listed in special tables.

Operation of Microprocessor Controlled Flash Units

If you look at the left side of the schematic, you will see the standard electrical circuit used for electronic flash units.

The Flash Discharge Circuit: A flash capacitor is charged via a voltage transformer, which converts low-voltage direct current (DC) from batteries into AC voltage raising it to approximately 300 to 600 volts, via a rectifier. This capacitor stores the maximum energy available for each flash. As a result, the ignition coil first generates a short high-voltage firing pulse of approximately 1.5 to 3 kV. Then the stored flash energy of the capacitor is discharged at a voltage of approximately 500 volts. The noble gas atoms in the flash tube which have been ionized and highly excited due to the discharge, release the electrical and thermal energy in the form of visible light. The duration of the discharge is a function of the size and content of the flash tube, the flash voltage and the resistor conditions in the electrical discharge circuit. At full output, the SB-25 has a lighting time (LT 1/1) of about 1/1000 sec. and at LT 1/64 of only about 1/23000 sec. Because the switching transistor may act to switch the current on and off, the lighting duration may be controlled directly via the on-time. This would, effectively control the released quantity of light.

TTL flash metering in the camera: The light reflected by the film surface is measured in the camera during the flash exposure. When the quantity of light measured relative to the sensitivity of the film corresponds to the correct exposure, a control pulse is generated

Flow chart of a microprocessor-controlled TTL flash unit

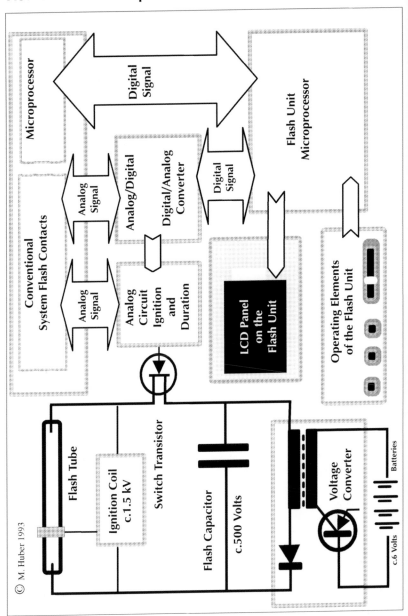

© M. Huber 1993

to stop the flash discharge. While in some conventional cameras this is still done via analog circuit technology, all actual and nominal values are largely computed digitally in the microprocessors of modern AF cameras. Only then, via systems contacts, will these cameras output signals converted into analog voltage pulses. As a result, even the most modern, fully electronic AF cameras are completely compatible with the older TTL system flash units. (Detailed information regarding the topic of TTL flash control can be found in the main chapter "The Basics of Flash Technology").

Analog feedback control for flash duration: The analog circuit controlling the flash discharge through the switching transistor receives an electrical pulse from the camera through the systems contacts, this fires and switches off the flash.

Variation of flash power in manual flash mode: Principally, the maximum energy releasable by switching several flash capacitors on or off could be preset. Another possibility would be the integration of resistors in the flash discharge circuit or a precise control in the switching transistor resistance. However, in the case of the SB-25 the flash performance is determined by the default setting of the flash duration. Instead of being variable due to the TTL metering in the camera, this predetermined setting takes effect via the operating buttons on the LCD panel. (Detailed information regarding this topic can be found in the chapter, "The Basics of Flash Technology").

Analog data transfer between flash unit and camera: Cameras permitting TTL flash control provide information transfer in the form of control voltages from the flash unit to the camera. Depending on the camera model, an LED flash indicator in the viewfinder is actuated to signal that the flash is ready to be fired and to verify adequate flash exposure. Most camera models automatically select an appropriate shutter speed (flash sync. speed) when the flash unit is activated. Even the automatic actuation of the flash unit from "Standby" takes place via analog signals. Although most modern cameras and flash units with built-in microcomputers are capable of digital transfer of information, Nikon generally uses analog transfer to assure compatibility of modern cameras with older flash units or older cameras with modern flash units.

The flash unit's microprocessor: The microcomputer's main job is to establish the connection between the "user surface" (buttons and the LCD panel) and the internal control electronics. On the other hand, the microprocessor may also send digital information directly to the camera and receive digital information from the camera for evaluation. This does not necessarily require additional systems contacts because, as a rule, digitized information may easily be added to the analog lines.

Digital data transfer between flash unit and camera: On N90/F90, F4 and N8008/F801 cameras, the duration of the flash is corrected on the SB-25 and digitized values are sent to the camera's computer which uses them in the computation of the TTL-controlled flash exposure. Conversely, the N8008/F-801, F4 and N90/F90 cameras use digital transfer of the film sensitivity, the aperture opening and focal length of the lens to the SB-25 microcomputer. It uses these values to compute and indicate the distance range of the flash and/or the automatic adjustment of the motorized zoom. Depending on the camera model, the flash synchronization for the second ("REAR") shutter curtain is set on the camera (N6006/F-601) or on the SB-25 (N90/F90, N8008/F-801). This example proves that, thanks to bi-directional analog and digital signal transfer, the SB-25 is compatible for use with many diverse camera models .

Specifications

Electronics: Microprocessor-controlled flash unit with bipolar insulating layer switching transistor (IGBT, Isolated Gate Bipolar Transistor).
Flash duration: 1/1000 to 1/23000 sec.; in manual, a function of output level (see table below).
Color temperature: Approximately 5600°K, (absolutely neutral in my tests).
Guide number: The guide number is a function of the zoom head position and the ISO film speed (see, "The Basics of Flash Technology!"). With ISO 100, the values listed in the table above apply.
Zoom head: Motor-driven, can be set between 24mm and 85mm. This is set automatically when the flash is used with the N8008/

Output	1/1	1/2	1/4	1/8	1/16	1/32	1/64
Flash Duration	1/1000s	1/1100s	1/2500s	1/5000s	1/8700s	1/12000s	1/23000s

Zoom head Focal length	20mm	24mm	28mm	35mm	50mm	70mm	85mm
Coverage horizontal/vertical	102°/90°	78°/60°	70°/53°	60°/45°	46°/34°	36°/26°	31°/23°
Guide number ft/m	66/20	98/30	105/32	118/36	138/42	157/48	164/50

F-801, F4 and N90/F90 cameras and AF lens systems. An additional, manually activated wide-angle panel for coverage of a 20mm lens is provided.

Auxiliary reflector/diffuser: Used with bounce flash exposures to attain highlights (such as, in the eyes).

Tilting flash head for close-up and bounce flash: With vertical stops from -7° to + 90°, horizontal from -90° to +180°. Locks automatically in standard position.

Power sources: Four AA alkaline manganese or four AA 1.2 volt NiCd batteries.

Additional external battery packs SD-7 or SD-8; see also "Power Options" in the chapter on "Using the SB-25."

Flash recycling and number of flashes: With four fresh AA alkaline manganese batteries at a temperature of approximately 68°F (20°C), approximately 100 full-output flashes may be triggered with a recycling time of 7 to 30 seconds.

Standby: The SB-25 is automatically switched off

approximately 80 seconds after firing a flash. With more modern cameras, lightly touching the camera release will automatically reactivate the SB-25.

Flash modes: "TTL" (via the TTL sensor built into the camera); "A" (non-TTL with integrated flash sensor); "M" (fully manual setting of the flash output and f/stop appropriate for the distance); "Stroboscopic Flash".

Variable flash output (manual flash): Seven variable power increments from 1/1 (full) to 1/64. Additional control of the light output is possible in up to 19 steps, in 1/3 stop increments with N90/F90.

Synchronization: Select between first ("NORMAL") and second ("REAR") shutter curtain sync. Slow synchronization ("SLOW") with all appropriately equipped cameras (strictly speaking this is not a feature of the flash unit); FP (continuous flash discharge corresponding to synchronization at high shutter speeds of 1/250 to 1/4000 second - N90/F90 only).

Flash control: The flash unit's ready-light signals when the flash is sufficiently charged.

Low-light (insufficient flash) indicator with exact numerical values: Only with the N90/F90 camera up to -3 EV, in increments of 0.5.

Test flash function: The indicator, or ready-light is combined with a manual release for test-flash use. Function "A" measures the reflected light via the sensor in the flash unit. See also the section "Flash Control" in the main chapter, "Operation."

AF-illuminator: Assists focusing in low light or even darkness with all Nikon AF SLR cameras.

Flash unit mounted in the shoe: This confirms that the flash is mounted with the flash contacts properly aligned for good connection with the camera

Red-eye Reduction: Only with the N90/F90 camera (see, related section in this manual).

Monitor Preflash: For fine-tuning the automatic exposure; only with the N90/F90 camera (see related section in this manual).

Liquid Crystal Display (LCD): Displays all important nominal and actual values in a clear manner!

Display illumination: LCD panel can be illuminated for about 8 seconds.

Rangefinder scale: Readily convertible between meters and feet.

Dimensions: Approximately 3 x 5-1/4 x 4″ (79 x 135 x 101mm) W x H x D.
Weight: Approximately 13.3 ounces (380g.) without batteries.
Carrying case: Standard equipment.

Film Sensitivity Range

The film sensitivity of the SB-25 ranges from ISO 3 to 8000. This range is restricted by the electronics of the camera that is used with the flash (with TTL autoflash).

Distance and Aperture Ranges

The possible variation of aperture and distance range is a function of the film sensitivity with non-TTL automatic and TTL flash operation. The information given below reflects only the most significant critical values.

Apertures and Shooting Distances in Non-TTL Automatic "A"

Film sensitivity range: ISO 25 to 1600

Aperture range:	f/1.4	to f/5.6	at ISO 25
	f/2	to f/11	at ISO 100
	f/4	to f/22	at ISO 400
	f/8	to f/32	at ISO 1600

Distance range: 2 - 66′ (0.6m to 20m).

Aperture and Shooting Distances with TTL Autoflash

Film sensitivity range: ISO 25 to ISO 1600

Aperture range:	f/1.4	to f/8	at ISO 25
	f/1.4	to f/16	at ISO 100
	f/1.4	to f/32	at ISO 400
	f/2.8	to f/32	at ISO 1600

Distance range: 2 - 66′ (0.6 to 20 m).

SB-25 Accessories

Cords and Adapters

TTL Remote Cord SC-17 for "off-camera" flash: One end of this 4.9' (1.5 m) coiled cable has a flash connector which mounts on the flash shoe of all Nikon cameras equipped with Nikon system contacts. When mounted on the shoe, the SC-17 relays control signals such as flash readiness status, TTL control, etc. The other end of the cord has a flash shoe and two multi-flash sockets for attaching any Nikon system flash or for connecting additional flash units using SC-18 or SC-19 cords. With the N2000/F-301, N5005/F401, N6006/F-601, N8008/F-801, F4 and N90/F90 cameras, the SC-17 permits unrestricted TTL flash photography with all camera-specific options (even Matrix-balanced fill-flash exposures). The SC-17 is indispensable when using the SB-25 with a "Stroboframe" flash bracket (see below!).

TTL Remote Cord SC-17

TTL Remote Cord SC-24 for the F4 camera: Permits unrestricted TTL flash exposures with all camera-specific options when using the F4 with the Waist-Level Finder DW-20, or the 6x High Magnification Finder DW-21 (neither of which have a flash mounting shoe). The SC-24 is a 4.9' (1.5 m) coiled cable.

Cords and Adapters for TTL Multiflash

The TTL-Multiflash-Sync Cords, SC-18 and SC-19 have terminals on each end for connection with Nikon multiflash system components (such as TTL Remote Cord SC17, Multiflash Adapter AS-10, and Nikon system flash units including the SB-25).

The SC-18 cord has a length of 4.9 feet (1.5 m) and the SC-19, 9.8 feet (3 m). See section, "Multiple Flash".

TTL Multiflash Sync Cord SC-18

TTL-Multiflash Adapter AS-10: For multiple flash with more than three units. One flash unit may be mounted directly on the shoe of the AS-10 and additional flash units may be connected to one of the three multiflash sockets using an SC-18 or SC-19 cord. See section, "Accessories for TTL Multiflash" (p. 95).

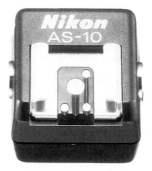

TTL-Multiflash Adapter AS-10

Adapters for the Nikon F3
Flash adapter AS-4: For use when the SB-25 is to be mounted on the F3 camera's special flash shoe.
Important: The flash readiness status is transmitted, however only automatic operation without TTL is possible.

Flash coupler AS-7: Allows film rewinding and opening of the F3 camera back while the SB-25 is mounted; only the flash readiness status will be transmitted and only automatic operation without TTL is possible.

Variable "Stroboframe®" Flash Brackets

Nikon does not offer a comparable flash bracket, nevertheless I consider Stroboframe brackets useful for discussion at this point. These innovative flash brackets have been manufactured and successfully marketed for years by The Saunders Group in the United States.

Sturdy, sensible modular design: The basic principle of this particular model is a sturdy, lightweight aircraft aluminum frame with ergonomically molded grips. Electrical or mechanical cable releases may be accessibly mounted in or near the side grip. The top bar of the bracket features a 1/4"-20 screw for attaching dedicated cords or it also accepts standard flash mounts which are modular designed. The flash mount on the SC-17 remote cord may be securely attached with the standard 1/4"-20 screw. At the base of the bracket is a platform which holds the camera securely. Beneath that is an comfortable, ergonomically-shaped palm grip.

Advantages of using a Stroboframe bracket: Many professional photographers prefer to use off-camera flash because it offers better lighting control. Direct, on-camera flash is often harsh and unnatural with heavy, hard-edged shadows. When the flash is too close to the lens, "red-eye" can occur. This is a condition caused by the light from the flash reflecting from the inner eye, resulting in an unattractive, "blood-shot" appearance. One solution is the use of bounce flash, but this technique has its own problems and limitations. Factors such as ceiling height, texture or color can often cause unpredictable results.

A simple way to avoid undesirable results in flash photography is a well-designed bracket such as Stroboframe. Using a bracket raises the flash to the correct height for a natural lighting effect. Shadows fall behind and below the subject and harsh edged "ghost shadows" are eliminated, even when the subject is close to the background.

One very interesting benefit of using a Stroboframe bracket is that

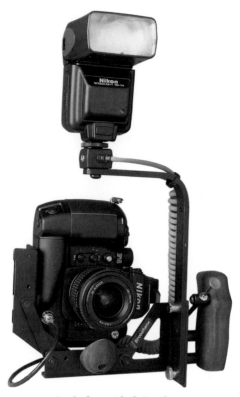

Stroboframe Flash Bracket

the camera platform can be rotated quickly and easily between horizontal and vertical formats. The advantage is that the flash remains, at all times, centered above the camera in the same position for high, natural-looking lighting. Even though the SB-25 by itself can be tilted for vertical and horizontal formats, the bracket maintains the ideal high-above-the-lens, flash position. Also, time-consuming, renewed positioning of the flash head is not necessary.

With Stroboframe, the SB-25 also becomes a photojournalist's flash: It used to be that photojournalists would almost exclusively use side-mounted, handle-type flash units. One reason was that

the bar-style bracket provided a secure support for the entire flash/camera combination, which is of great advantage when being jostled. Compared with this the combination of say, an N90/F90 or N8008/F-801 camera with the SB-25 mounted directly on the shoe is rather unstable in ones hands. In addition the connection between flash unit and camera is rather rigid so that impact with the flash unit might damage the camera's accessory shoe or the flash unit. A sturdy, well-engineered, Stroboframe Flash Bracket solves this problem. Along with the many lighting advantages listed above, Stroboframe brackets are a distinct advantage for photojournalists as well as many other photographers.

Camera Compatibility

Most of the SB-25's automated features are only fully realized ⇨ when it is used with the N90/F90 camera. However, it is also compatible with other Nikon camera models. This means, (ranging from the F4 to the N8008/F-801, and even including the classic F2 camera) that it is ultimately the camera's electronics which determine the capabilities of the SB-25.

Compatibility of the SB-25 with Nikon Cameras

	N90 / F90	F4	N8008s / F-801S	N6006 / F601AF	N5005 / F-401x	F401 / F-401s	N2020 / F-501	N2000 / F-301	FA	FW2	FG	F3	F2	FM2	FG-20
FP-high speed synchronization (up to 1/4000 s shutter speed)	•														
Second (REAR) shutter curtain Synchronization	•	•	•	•											
Preflash for red-eye reduction	•		•												
3D-matrix-TTL-multisensor flash with measuring flash	•														
2D-matrix-TTL-multisensor flash	•		•	•											
Matrix-balanced TTL fill-flash	•	•	•												
TTL fill-flash with center-weighted continuous light measurement	•	•	•	•											
TTL fill-flash with continuous spot measurement	•	•													
Programmed TTL autoflash	•		•	•	•	•	•	•	•						
Standard TTL flash	•	•	•	•	•	•	•	•	•	•	•	•		•	•
Standard TTL flash in the macro range	•	•	•	•	•	•	•		•	•	•	•		•	•
Non-TTL automatic flash mode	•	•	•	•					•	•	•	•	•	•	•
Fully manual flash mode	•	•	•	•	•	•	•	•	•	•	•	•	•	•	•
Manual flash mode with reduced flash output	•	•	•	•	•	•	•	•	•	•	•	•	•	•	•
Stroboscopic flash mode	•	•	•	•					•	•	•	•	•	•	•
Manually adjustable flash exposure correction	•	•	•	•					•						
Consecutive flash exposures	•	•	•												
Standby with automatic reactivation	•	•	•	•	•	•	•	•	•	•	•	•	•	•	•
Test flash (with flash unit sensor)	•	•	•	•	•	•	•	•	•	•	•	•	•	•	•
Non-TTL-multiflash	•	•	•	•					•	•	•	•	•	•	•
TTL-multiflash	•	•	•	•	•	•	•	•	•	•	•	•		•	•

Operating Controls and Features

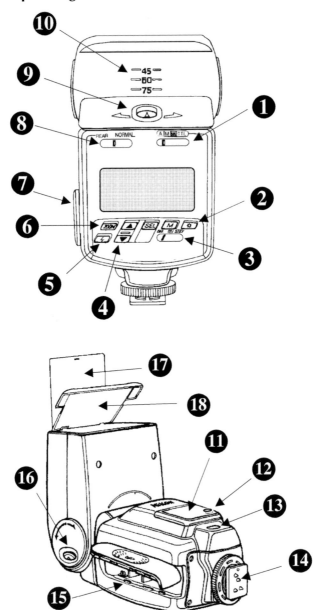

1) Mode selector switch.

2) LCD illuminator button, next to "M" button (selection of output levels, reversal to standard TTL),), next to "SEL," selector button (selection of function fields: film sensitivity, f/stop, exposure correction).

3) Power switch.

4) Arrow, adjustment buttons for setting numerical values such as film sensitivity, f/stop, exposure correction.

5) Flash ready light combined with test-flash button and flash control indicator light.

6) Zoom button for manual setting of the the flash zoom head.

7) TTL-Multiflash connection, and standard (ISO) flash sync contact (under protective cover).

8) Switch for flash sync selection of either the first ("NORMAL") or second ("REAR") shutter curtain.

9) Lock release for rotating the flash head.

10) Vertical angle scale for tilt or bounce flash.

11) AF-Illuminator (auxiliary LED beam, assists automatic focusing in low light or darkness).

12) Sensor for non-TTL automatic flash, "A."

13) Plug for external power supply (with protective cover).

14) Mounting foot with flash contacts (central conventional ISO contact; in addition, 3 systems contacts plus an additional locking pin for N90/F90).

15) Battery compartment (with selector switch for meters or feet).

16) Lock release for tilting the flash head.

17) Auxiliary diffuser which can be pulled out for highlights with bounce flash.

18) Wide-angle flash panel can be pulled out and down for full coverage of a 20mm lens.

Liquid Crystal Display

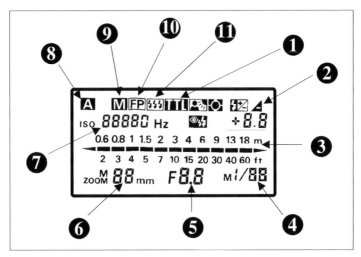

1) TTL Mode symbol (signals operating mode "TTL," when standard "TTL" is displayed), next to this the symbol for automatically-controlled TTL fill-flash, next to this the symbol for automatically-controlled TTL multisensor fill-flash (N90/F90).

2) Indicator for exposure compensation; N90/F90 also has flash control field (displays possible underexposure value in f/stops), to the left of this, the symbol for red-eye reduction (N90/F90 only).

3) Distance scale: continuous bars indicate the distance range (with TTL and non-TTL automatic; individual bars indicate the approximate distance with manual flash "M," stroboscopic flash, and FP flash.

4) Light output level display (and adjustment) indicator and the FP indicator.

5) Display or adjustment field for aperture; depending on the operating mode, this represents the nominal or actual value.

6) Display or adjustment field for the zoom head, depending on the camera and lens, automatic or manual adjustment. (The focal length of the lens should correspond or be greater.)

7) Display and adjustment field for film speed (ISO) number and flash frequency with stroboscopic (repeating) flashes.

8) Symbol for non-TTL automatic flash mode, "A."

9) Symbol for manual flash mode,"M."

10) Symbol for high-speed synchronous flash "FP" (only in conjunction with "M").

11) Symbol for stroboscopic flash.

Using the SB-25

The following chapter is meant to provide you with a brief but thorough explanation of the operation of the SB-25. Now that you have invested in this state-of-the-art flash unit, it would be a pity if you utilized only a fraction of the many options offered by your camera/flash combination. Therefore, it is highly beneficial to totally familiarize yourself with its operation.

Step-by-Step Operation

Following is a brief introduction to the steps in basic operation of the SB-25, with brief references to common problem areas, sources of misunderstandings, etc.

Loading the Batteries
It is obvious but nonetheless important that the batteries are inserted in the battery compartment with the contacts properly aligned. See also the section "Power Options."

Setting the Film Speed
The film sensitivity is transferred automatically to the SB-25 only when N90/F90, F4 and N8008/F-801 cameras are used. All other cameras require the setting of the ISO film speed on the SB-25 itself:

❐ Use the SEL button to select the film speed field on the LCD.
❐ It blinks.
❐ The value may now be set with the arrow keys.

Mounting the Unit on the Camera
Be sure that the flash foot is seated properly in the camera's flash shoe, then tighten the locking screw. (See also,"Flash control").

Selecting the Flash Operating Mode
Use the sliding switch to select the main operating mode between

TTL autoflash - "TTL," stroboscopic - "multiflash symbol," manual flash - "M," and non-TTL automatic flash - "A." The selected flash mode is indicated on the LCD panel. The flash operating modes are explained in the chapter "Flash Modes and Methods of Use."

Selecting the Synchronization
For general photography, the sliding switch should be set on "NORMAL." "REAR" should be used only in conjunction with slow synchronization and with cameras that feature second shutter curtain sync.

Adjusting the Zoom Head
When AF and AI-P Nikkor lenses are used in conjunction with N8008/F-801, F4, and N90/F90 cameras the zoom head is adjusted automatically. With NON-AF Nikkor lenses or with all other cameras the zoom head must be adjusted manually by pushing the zoom button. With all cameras, the 20mm diffuser panel must be pulled out and down manually.

Varying the background brightness: Using manual aperture adjustment and standard TTL autoflash with a synchronization speed of 1/125 sec., one flash exposure was taken at f/5.6 (top left) and one at f/11 (top right). Because the smaller aperture opening prevents the ambient light from being registered, the background becomes darker. This example shows that with the use of standard TTL control and a not-too-light background, reasonably good results are possible without special automatic fill-flash.

Red-eye reduction: Thanks to the 3D-TTL-multisensor and automatic fill-flash used with an N90/F90 camera, this close-up, snapshot portrait of two children was a success! And thanks to the preflash feature, red-eye doesn't appear in the finished photo.

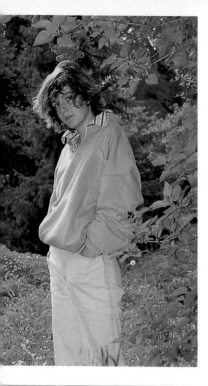
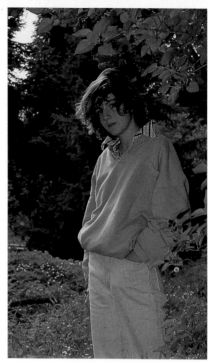
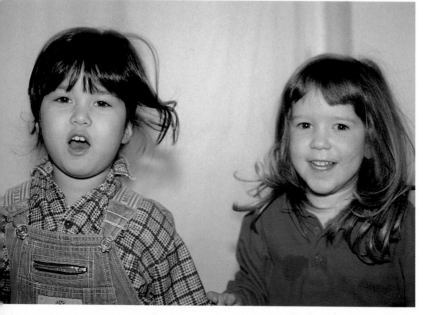

Flash Head Position

The normal locked position is facing forward. To adjust the flash head position, the lateral lock lever must be released. If the -7° tilt feature is in use, the range indicator blinks to remind the user that the.flash head is not in the normal position. In any other "non-normal" position such as bounce, the distance scale is blank since the flash cannot gauge what the potential range would be.

Determining the Distance for a Preset Aperture

When using the flash modes "M" and "TTL," in conjunction with the N8008/F-801, F4, and N90/F90 cameras and AF and AI-P Nikkor lenses, the selected aperture value is automatically transferred to the SB-25. With NON-AF Nikkor lenses or with all other cameras the f/stop must first be set on the lens and then again, manually on the SB-25 for correct exposure range information.
❏ Press the SEL button.
❏ Aperture position on the LCD blinks.
❏ Adjust with the arrow switches.
The LCD display indicates the correct distance setting (manual flash) or the flash range (TTL flash) in the form of bars on the range scale.

Determining the Aperture for a Pre-determined Distance

To accomplish this, N8008/F-801, F4, and N90/F90 cameras used in conjunction with AF and AI-P Nikkor lenses, require that the aperture be adjusted on the camera lens until the LCD on the SB-25 indicates the desired distance or distance range. With the use of NON-AF Nikkor lenses or with all other cameras, the aperture must be adjusted on the SB-25 until (see above) the desired distance setting is indicated on the LCD display; this aperture value is then also set on the lens.

Studio-type lighting with the use of TTL-Multiflash: This picture was taken with the N90/F90 and an AF-D Nikkor lens in 3D- TTL-multisensor automatic fill-flash, but with a manual adjustment of the aperture (f/16 at 1/125 sec.). The SB-25 was positioned on a diagonal axis from the right rear and, in addition an SB-23 was used diagonally from the left rear. The flash units were aligned by using home-made "modeling lights" (reflector lamps clamped underneath the flash). Thanks to the automatic flash features, the exposure was perfect and, due to targeted positioning and alignment of the flash units, it was possible to make the pewter shiny, as well as make the glass "luminous."

Changing the Output Level

In "M" mode the M button may be pressed for a continuous selection of flash output from 1/1 (full) to 1/64.

Flash Exposure Compensation

If your camera allows, you may make flash exposure adjustments in TTL mode on the SB-25. The SEL-button is used to activate the correction field on the LCD and then the arrow keys are used to select the desired correction value.

Power Options

Battery Choices

Theoretically, all 1.5-volt batteries, size AA may be used in the SB-25, whether they are alkaline manganese, zinc carbon, or lithium. As an alternative, rechargeable NiCd batteries of this size may also be used.

Alkaline manganese: AA alkaline manganese batteries are available in almost any camera store, "mom and pop store" or in any supermarket. These certainly continue to be the most popular power source.

Zinc carbon batteries: These are less expensive, offer lower capacity, are not stable when stored, and their low-temperature response is poorer than that of alkaline manganese batteries. Hence, they should be used only in emergencies. (Modern zinc carbon batteries do not contain mercury.)

Lithium batteries: 3-volt and 6-volt lithium batteries have been sold for some time. Now they are also offered in 1.5-volt AA size. Theoretically, they would be the ideal emergency back-up for camera and flash units because of their practically unlimited shelf life (only approximately 10% self-discharge in 10 years). It remains to be seen whether these new 1.5-volt, AA lithium batteries will have the high power carrying capacity required by flash units. At this point, Nikon is currently recommending against the use of the 1.5-volt AA lithium battery for use in its products. If you are interested in the possibility of using these batteries in the SB-25, I would recommend keeping yourself updated on the acceptance of these batteries by Nikon for use in flash units.

NiCd ("Nicad") batteries: Because nickel-cadmium batteries

exhibit higher power carrying capacity than other types of batteries, they feature a faster flash recycling time and are suitable at low temperatures. Their overall capacity, however, is lower and therefore they last only for approximately 1/3 of the number of flashes compared with alkaline manganese batteries. Also, since NiCd batteries exhibit a considerably greater self-discharge than alkaline manganese batteries, they are recommended with reservations. Only freshly charged nickel-cadmium batteries should be used. Theoretically, modern NiCd batteries are capable of up to 1000 charging cycles when used with a good charging unit. Also they may be a sensible alternative from an economical, as well as ecological, viewpoint. In practice, however, the capacity of NiCd batteries is reduced significantly due to the so-called "memory effect" after having been used only about 10 to 20 times or even after extended non-use. Cells damaged by this effect can sometimes be regenerated by repeated charge/discharge cycles. A charging unit with automatic charge/discharge function ("refresher") should be used. For continuous use, an automatic "maintenance" charge is advantageous.

Caution: Defective NiCd storage batteries should always be disposed of properly!

Battery Compatibility

Never combine different types of batteries: Due to their different internal resistances, battery types should not be mixed. The combining of alkaline manganese with carbon-zinc cells or NiCd batteries may result in rapid inherent destruction of the combined batteries. And, because these combined batteries may burst and leak, the flash unit could also be seriously damaged!

Risk of Leakage

With the normal use of batteries, and even in the case of self-discharge during non-use, moisture is formed inside the cell. This results in an aggressive mixture which, in the course of time, will corrode the battery shell. If this battery fluid reaches the electronic elements of the flash unit, they will be damaged Considering the external dimensions and the electrical performance, it is technically impossible to manufacture absolutely leak-proof batteries. As far as I know, this has been the reason why battery manufacturers have quietly withdrawn their "leak-proof" guaranties during

recent years. Therefore, because of this risk of leakage, as a pre-
caution, always remove the batteries from the flash unit during
extended periods of non-use!

Disposal or Recycling

Only batteries which have been clearly labeled "mercury-free
and cadmium-free" should be disposed of as household waste. All
batteries, particularly NiCds, should go to recycling centers, when-
ever possible. Some battery manufacturers are beginning to offer
this service.

External Power Sources and Accessories

Power cord SC-16: This cable is used to connect the SD-7 battery
pack with the SB-25. (The SD-8 has a permanently attached cord).

Battery pack SD-7: This external battery pack reduces the flash
recycling time while increasing the number of flashes approxi-
mately two to four times. It is used in addition to the alkaline or
NiCd batteries present in the flash unit. With the SD-7, the SB-25
can be successfully used at low temperatures.

Battery pack SD-8: Used along with the alkaline or NiCd batteries
in the flash unit, the SD-8 will reduce the flash recycling time (with
NiCd batteries to approximately 2 seconds). Also, the recycling
time is reduced in low temperatures with the addition of an SD-8.
The SD-8 does not effectively increase the number of flashes as
much as the SD-7.

Care During Rapid Consecutive Shooting

Excessive, rapid recycling depletes batteries! The rapid charging
of the flash capacitor requires considerable electronic energy. This
causes the batteries to heat internally resulting in internal self-dis-
charge and greatly reduced capacity. However, if a period of
approximately 30 to 60 seconds elapses between individual
flashes, excessive heating does not occur and a maximum num-
ber of flashes becomes possible.

Excessive, rapid recycling damages the flash unit! Repeated, rapid
consecutive firing can also result in an overheating of the flash
tube and the flash unit's electronic elements, eventually causing

Battery Pack SD-8

their destruction. Therefore, Nikon recommends only a maximum of 15 consecutively fired flashes, regardless of whether TTL auto-flash, non-TTL automatic flash "A", manual flash [1/1 (full) and 1/2], or stroboscopic flash mode is used. Only in manual mode with a reduced flash output of less than 1/2 power are more than 15 consecutive flashes allowed (for example, 40 at 1/4 output).

Batteries and Cold Conditions
In cold temperatures the internal resistance of batteries rises substantially and the effective capacity drops dramatically. In this case only fresh alkaline manganese batteries which have been kept warm, or freshly charged NiCd batteries should be used. For best results, the use of external battery packs (see above) is recommended.

Summary of Battery Recommendations
These apply to AA alkaline manganese or NiCd batteries used with the SB-25.

Combining different types of batteries: Not permissible (see above)!

Storage: Cool (but not in the freezer!) and dry to reduce self-discharge.

Number of flashes and recycling time as a function of power supply at 68°F (20°C).

Type of power supply	Batteries	Number of flashes* (approx.)	Recycling time* (approx.)
Internal	4 AA-size Alkaline Manganese	100	7 - 30 sec.
Internal	4 AA-size NiCd batteries	40	5 - 30 sec.
Additional external w/ SD-7	6 C-size Alkaline Manganese	200 - 400	3 - 30 sec.
Additional external w/SD-7	6 C-size NiCd batteries	140	1.6 - 30 sec.
Additional external w/SD-8	6 AA-size Alkaline Manganese	100 - 250	3 - 30 sec.
Additional external w/ SD-8	6 AA-size NiCd batteries	100	2 - 30 sec.

* Rule of thumb: The maximum number of flashes is possible only when the time period between flashes is long, i.e., with fast recycling times the effective number of flashes is reduced.

Back-up batteries: Even when NiCd batteries are used, it is a good idea to always keep a spare set of fresh batteries.

Care in cold environments: In winter, for example, you should keep spare batteries in a warm shirt or trouser pocket.

Danger of leakage: During storage or extended periods of non-use, always remove the batteries from the flash unit.

Care of the flash unit

Maintenance

Over-cleaning of the flash unit may cause damage. Also, cleaning the housing with unsuitable fluids such as acetone, benzene or alcohol solvents may dissolve it. The use of water for cleaning could damage the electronics inside. Therefore, the housing should be wiped only with an antistatic cloth such as Bosch® and cleaning sprays recommended for electronic units. Never spray cleaner directly on the flash unit; instead, spray a small amount on a lint-free cloth and then wipe the housing.

Moisture Damage

Moisture and salt water destroy electronic elements! Moisture is a problem even with conventional electronic components; however, modern microprocessors will stop working if the surrounding air humidity is too high or if water gets inside the unit. Salt water spray is particularly corrosive (be careful with ocean mist!) and can easily result in permanent damage. *First aid:* Immediately switch off the flash unit, remove the batteries, and let the flash unit air-dry.

Precautions: A plastic pouch is ideal to protect your flash unit from rain, excessive air moisture, or when around water. For boating and water sports, water-tight, inflatable floating containers are recommended. However, never forget that condensation can easily form in tight plastic pouches and, as already mentioned, is not good for the electronic elements. Therefore, it is advisable to put the flash unit in a sealed container with a few packets of desiccant (or "silica gel").

Condensation: Extreme changes in temperature (often caused by going from an outside environment to internal heating or air conditioning, or the reverse) can cause condensation to form on the outside of the flash unit. If this occurs, wiping the surface and leaving the unit uncovered until it has air dried will help. It is recommended that you keep your camera equipment, including the flash unit, inside your camera bag until all of the equipment has reached the surrounding air temperature.

Functional Reliability of the Electrical Components

Cleaning contacts: Unfortunately the battery compartment and the mounting foot of the SB-25 flash unit do not have gold-plated contacts; hence, normal oxidation is likely to occur. This means that an oxide layer is formed on the contact surface which may decrease conductivity, even if this layer is imperceptibly thin. Therefore, from time to time, the contacts should be cleaned carefully with a fine pencil eraser.

Refreshing the capacitor during periods of storage: If you intend to not use the flash unit for an extended time, you should still load the batteries and turn the unit on occasionally. After the unit has reached full-charge, push the test flash button a few times. Then allow the unit to charge again and without firing it, switch it off. This procedure refreshes or reforms the flash unit's capacitor and maintains it in good working order. This trick maintains the flash unit's full performance power.

"Hands Off" the Internal Parts

Modern electronics are not designed for the "do-it-yourselfer!" Should you consider Nikon's service prices too high, you may find the problems caused by you or another untrained person even more costly. *Also, if you allow unauthorized repairs or if you open the flash unit during the warranty period, you will void the standard warranty offered by Nikon.*

The address is "Nikon Service:" Should your flash require repair, always send it to a Nikon authorized service center. This can be done by carefully packaging the unit and returning it to the nearest Nikon service center or by consulting your local photo dealer. And, incidentally, proof-of-purchase and a detailed description of the problem should always be enclosed!

Trouble-shooting

PROBLEM: Ready-light on flash does not light.

Error symptoms: The ready-light on the flash unit does not light up even if the unit is switched on, or it goes off again very quickly, or the charging period is considerably longer than 30 seconds.

Check batteries: Are the batteries installed in the unit correctly? Are they depleted? Are they of the same type? A small, commercially available "battery checker," which can be purchased inexpensively is quite handy or a voltmeter allows a more precise check: A reading of over 1.5 volts in each AA-type cell is quite adequate for alkaline manganese or carbon/zinc batteries as is a reading above 1.25 volts for NiCd batteries. Fresh batteries should give a reading of 1.55 to 1.65 volts, freshly charged NiCds, 1.35 to 1.45 volts. In a pinch, using the trial and error method, replace the entire set of batteries with a fresh or freshly charged set. Remember also to clean the battery contacts.

PROBLEM: Flash cannot be fired.
Error symptom: Even though the ready-light on the flash unit is lit, the camera shutter cannot be released.

Causes: Either there are contact problems (see below) or the selected automatic flash features do not work with your camera/lens/flash combination (see below). Even in the case of flash unit or camera processor "overload" it is possible for such phenomena to occur (see below!).

CONTACT PROBLEMS:
Error symptoms: The flash LED (if your camera has one) in the camera viewfinder does not light up, or it flickers. Required readings are not displayed by the LCD of the flash unit as you expected. Certain functions of the flash unit such as, the automatic adjustment of the film sensitivity, the zoom head, and the aperture number do not work. The flash cannot be fired via the camera release even though the ready-light on the flash unit is lit.

Check contacts: See the section, "Functional Reliability of the Electrical Components" above. It is possible that the battery contacts need to be cleaned. *Cleaning shoe contacts:* The system contacts on the mounting shoe should also be gently cleaned from time to time.

Check for correct alignment in the shoe: Regardless of the manufacturer, whenever I attach a flash unit quickly, there is a 50:50 chance that the contacts will not be aligned properly. Therefore,

care must be taken that the flash unit is inserted all the way into the camera's shoe until resistance is met. Then tighten the locking screw without shifting the foot. (The best solution is offered with the N90/F90 camera, in this case a mount pin on the flash unit engages with a locking recess on the camera shoe.)

PROBLEM: Shooting distance indicator on the flash unit's LCD blinks.
Causes: This does not indicate an error in the flash unit but possibly an operator error. Blinking means that the flash head is set for -7° tilt or close-up; if this is not desirable you should lock it in normal position.

PROBLEM: Flash unit and camera settings do not match.
Error Symptoms: The flash unit does not do what you think it should do.

Check flash unit and camera settings: Check whether the desired matching functions are selected on the camera and flash unit. Maybe in the "heat of the battle" you have changed this or that in the meantime?
Are you in fact using the camera and lens types matching the desired automatic function? (For example, the film sensitivity will be transferred automatically to the SB-25 only when used with N90/F90, F4, and N8008/F-801 cameras. The focal length and aperture opening are transferred only with AF lenses.)

PROBLEM: Overload.
Error symptoms: The flash cannot be triggered from the camera and/or the flash unit cannot be switched from one function to another. This does not include errors listed above.

Causes of overload: Electrostatic charges or signals which do not meet the standard for voltage or timing may once in a while "get out of control" in microprocessor-controlled cameras and flash units. (This is not a problem exclusive to Nikon.)

Camera overload: The shutter cannot be released even after removing the flash unit; the liquid crystal display blinks "senselessly;" operating modes cannot be reversed; the camera can no

longer be switched off with the main switch; the mirror does not return to its resting position.

Recommendation: Move the main switch to "Off" and remove the batteries from the camera for a few minutes. (This allows the camera's microprocessor which has been blocked by error information to discharge electrically so that it is again ready for operation.) Your camera should function again after two or three tries. Should this phenomena occur frequently, however, it is likely that a chip is defective and you should have the camera serviced by Nikon.

Flash unit overload: Unfortunately, even the SB-25 can occasionally overload. It may happen, for example, that the camera cannot be switched from "TTL" to "M." The camera must be switched off; then the flash unit switched off and removed from the camera. After remounting and reactivating the flash unit, it should be possible to again switch between operating modes.

Power overload: If too many flash units are connected with each other in TTL-controlled multiple flash mode, it is possible that a second flash burst cannot be fired. The main unit must be disconnected from the camera, all the flash units briefly switched off, then be reconnected with the camera and switched on again. If necessary, use one less flash unit. (The number of admissible flash units can be found in the section "TTL-Controlled Multiple Flash Photography" (p. 94).

Flash Control Features

Flash-ready indicators: If the ready light on the flash unit and/or the flash LED in the camera viewfinder have been lit for at least 2 seconds, the flash unit is charged and ready for firing. Do not be misled by consecutive firing: You may trigger a flash immediately after the LED lights up, however, the unit's performance may not necessarily be quite at 100% yet!

"Confusing" existing light readout: In some cameras (such as, N8008/F-801 and N90/F90) the ambient light exposure as well as

the automatic read-out for shutter speed and aperture are shown when using TTL autoflash. If the readout indicates an over or under exposure, it refers strictly to the ambient exposure. If under exposure is indicated, and that area also will receive flash exposure, the resulting image may be OK. However, the over or under exposure warning indicates that existing light may not have been given proper consideration. For the best TTL fill-flash results, use matrix metering and automatic exposure; or use spot or center-weighted metering and selectively measure a specific area to establish a basic available light exposure. Then set the camera manually, or if in auto exposure, press and hold the AE-L (automatic exposure lock) button to lock-in the exposure before recomposing. Release the AE-L button after shooting.

Flash exposure control: If the flash's ready light or the flash LED in the camera viewfinder blinks several times or goes off completely after firing, the flash was too weak. The causes of this are generally a subject which is beyond the distance range or a film sensitivity which is too low (or depending on the automatic features, the aperture opening was insufficient). In this case, underexposed pictures will probably result. The solutions are using a larger aperture opening, a faster film, or moving closer to the subject!

Underexposure indication in f/stops (N90/F90): When using the N90/F90 camera the flash LCD may indicate an underexposure in TTL-controlled flash mode up to -3 EV in 0.3 f/stops. Due to this indication, the aperture (if at all possible) may be opened accordingly or another distance may be selected.

"HI" indication (F4, N8008/F-801, N90/F90): The overexposure indication "HI" which appears in the viewfinder of the cameras, listed above, applies only to the ambient light reading. This generally indicates (usually in situations where backlighting is present) that the background will be too light even when using the smallest possible aperture opening. However, the foreground which has been lit by the flash should be correctly exposed assuming that it isn't also subject to the same or similiar level of ambient light.

Test flash: A test flash may be fired with the SB-25 (without film exposure) by manually triggering the flash unit. A test flash is not appraised by the TTL metering system in the camera; it is only read by the sensor built into the flash unit. If the ready-light on the flash unit stays lit after a test flash, the flash output will probably be sufficient for good exposure. If you are using TTL mode, you must switch to "A" to operate the test flash feature.

Flash Modes and Methods

The SB-25 features three different standard flash modes: TTL auto-flash (**TTL**), non-TTL automatic flash (**A**) and manual flash (**M**). In addition, there are two special flash functions, stroboscopic flash (**Multiple Flash symbol**) and high-speed synchronization (**FP**). Additional auxiliary features allow optional synchronization with the first (NORMAL) or second (REAR) shutter curtain, preflash for red-eye reduction, and monitor preflash. The mode you choose depends on the capabilities of your camera, on one hand and on the subject and specific picture-taking conditions, on the other hand. Ultimately, of course, the quality of the finished photo is the most important criterion. The following chapters provide help in selecting the best method for a given subject and anticipated end-result. An explanation of actual flash methods will be followed by a discussion of suggested combinations for use with the automatic exposure features of various cameras.

Classic, Fully Manual Flash

Principle
The photographer computes the correct aperture for the subject distance and film speed, or takes a flash meter reading and adjusts the aperture accordingly. The flash unit itself works with a default guide number (or optionally, the SB-25 also works with a reduced guide number, see below).

Suitable Cameras and Lenses
The SB-25 will operate in manual flash mode with all Nikon cameras and lenses. Adapters are available if your camera is not equipped with a "hot shoe."

◁ **An example of action flash photography using the SB-25 with the camera set on aperture priority automatic. Photograph: Rudolf Dietrich.**

Liquid crystal display (LCD) using manual flash mode.

$$\boxed{\text{M}}$$

ISO *ᵢ00*

0.6 0.8 1 1.5 2 3 4 **6** 9 13 18 m

ZOOM *35* mm *F5.6* M *1/1*

Manual Flash Operation

Note: The following explanations apply only to the SB-25 when it is attached to a camera. Different rules apply to flash exposures taken in the studio where the work is principally manual, however the flash units are separate from the camera (see the section "Studio Flash Photography" p. 107).

Procedure

❑ Mount the SB-25 to the camera accessory shoe and turn on the camera and flash.

❑ Set the ISO film speed on the SB-25.

❑ Select "M" mode on the SB-25.

❑ Set the SB-25's zoom head for the focal length of the lens.

❑ For F4, N8008/F-801, N90/F90 cameras, see below.

❑ Set other "classic" cameras to flash sync speed.

❑ Focus on your subject.

❑ Adjust the aperture on the lens and on the flash unit until the distance indicated on the SB-25's LCD corresponds to the subject distance.

❑ Press the shutter release.

❑ For control options, see "Flash Controls" (p. 55).

With practice, you should be able to perform the above steps quickly.

Cameras with TTL dedication: For cameras with dedicated TTL flash capability, the shutter speed of the camera is adjusted automatically to the correct flash sync speed. Other than that, proceed as described above.

Using N8008/F-801, F4, N90/F90 with manual flash: On these cameras the film sensitivity and the zoom head are adjusted automatically; also the selected aperture settings are automatically relayed from the camera to the flash.

❑ Set your camera on manual exposure or aperture priority and select an appropriate flash sync speed up to 1/250 second.
❑ Focus on your subject.
❑ In manual flash mode the LCD panel will "receive" the aperture settings from the camera automatically.

Limits of manual flash photography: When using just the guide number calculation, perfect flash exposures are almost always an exception. This is because the effective guide number fluctuates slightly as a function of flash recycling time, and also because ambient light and subject characteristics play an important role in the overall exposure. Manual flash exposures using a flash exposure meter are more reliable. The fact that the SB-25 indicates aperture readings only in steps, creates another inaccuracy factor.

Bracket your exposures: It is best to make a series of bracketed exposures, in fixed increments over and under the calculated exposure when using manual flash.

Selection of aperture and distance by varying the flash power output: In manual mode the guide number predetermines the aperture for a given distance from the subject. From an artistic viewpoint this is not always ideal. Because the SB-25 allows you to reduce the power output in 6 steps (using the M button), aperture and distance may be varied within a wide range. For example, if the 1/1 (full) output level requires f/8 for a distance of 13 feet, pictures may be taken at 1/4 power using f/4, and at 1/8 power using f/2.8. Conversely, if a desired aperture is to be maintained for certain reasons and one wants to be closer to the subject, the power output feature may be used to adjust for the distance change. For example, if the appropriate subject distance is 13 feet, with a constant aperture of f/8 and an output level of 1/1 (or full), it is possible to move to 2 feet with an output level of 1/64.

Precise adjustment of power output: When using manual flash, it is possible with the N90/F90 (only) to fine-tune the power output of the SB-25 in 1/3 f/stop increments by using the flash compensation scale accessed via the SEL button. This option is in addition to the output levels 1/1 (full) to 1/64. If one is attempting a series of finely-tuned flash exposures or transferring values from a sensitive hand-held flash meter, this method is significantly more accurate than adjusting the lens aperture. The latter should be set at a full value with the fine adjustment performed on the flash unit.

Manual flash with automatic flash sync: Effectively, this does no more than manual flash exposure. The only difference is that the shutter speed is automatically set for flash sync on cameras featuring this option. In some cameras which use matrix, center-weighted, or spot metering, the flash synchronization speed is varied automatically between 1/60 sec. and 1/250 sec. to match the ambient light and the selected aperture. (In slow sync these cameras can chose between 30 seconds and 1/250).

When to Use Manual Mode?
In some cases it is better than TTL autoflash mode: It has been my experience with the SB-24 and the SB-25, that for complex applications precisely adjusted manual flash is sometimes better than standard TTL autoflash exposure. (Even exposures using matrix balanced automatic flash are sometimes only equally as good as those made with manual flash). All subjects exhibiting high or unusual reflectance require careful evaluation with the use of standard TTL autoflash or even matrix balanced fill-flash. Of course, the best solution is 3D multisensor balanced fill-flash with monitor preflash and "D" lens distance information. Compared with this, manual flash photography no longer offers any advantages.

Manual Flash with Motor Drives or Winders
Autoflash modes are less suitable for continuous shooting: Due to longer flash recycling times, automatic flash modes are less suitable for continuous shooting. The risk that the flash may fail at precisely the most important moment because its capacitor is not fully charged, is simply too great. *Caution:* The SB-25 may overheat; therefore, in "A" and "TTL" modes no more than 15 flashes may be fired continuously.

Manual flash mode for continuous shooting: For quick recycling during continuous exposures select manual mode on the SB-25 and reduce the power output (between 1/8 and 1/64). In most cases, shorter subject distances and/or larger aperture openings must be used in order to accommodate this reduced output. The number of flashes which may be fired continuously are limited on one hand by the back-up capacity of the power supply, and on the other hand by the risk that the SB-25 may overheat. In any event, a fresh set of alkaline manganese batteries or freshly charged NiCds will allow the continuous firing of up to 30 exposures at 1/64 power and up to 4 exposures at 1/8 power at a rate of up to 6 exposures/sec. By using external power pack SD-7, the number of flashes may be increased by approximately 25%.

Non-TTL Automatic Mode "A"

Principle
The duration of the flash is controlled independently from the camera's electronic system via a sensor on the flash unit. In this case the sensor measures the light reflected off the subject during an exposure. The photographer may select any aperture covered by the range of the flash. (The SB-25 makes the choice of aperture very easy; many other flash units are more complicated.) Additional information can be found in the chapter, "The Basics of Flash Technology" (p. 122).

Suitable Cameras and Lenses
On fully manual cameras and lenses, or even with cameras featuring automatic exposure, the SB-25 may be used in non-TTL automatic flash mode "A." Appropriate adapters are available if your camera does not have a "hot shoe" with the ISO sync contact.

"A" Mode Operation

Procedure
❐ Mount the SB-25 in the camera accessory shoe and turn on the camera and the flash.
❐ Set the film sensitivity on the SB-25 (F4, N8008/F-801, N90/F90 below.)

Liquid crystal display (LCD) using non-TTL automatic flash mode "A."

A

ISO *100*

0.6 0.8 1 1.5 2 3 4 6 9 13 18 m
▄▄ ▄▄▄ ▄▄ ▄▄ ▄▄ ▄▄

ZOOM *35*mm *F5.6*

❏ Set the SB-25 to "A" mode.
❏ Set the SB-25's zoom head for the focal length of the lens in use (F4, N8008/F-801, N90/F90 cameras below).
❏ Make sure with "classic" cameras to set the correct flash sync speed (for F4, N8008/F-801, N90/F90 cameras, see below).
❏ Focus on your subject.
❏ Set the desired aperture on the camera lens.
❏ Also set this aperture on the LCD of the SB-25 and check to make sure that the distance range matches the focus distance on the lens.
❏ Optionally, change the aperture on the lens and on the flash unit until the proper distance range is reached.
❏ Now all you need to do is press the shutter release.
❏ For flash controls see "Flash Controls" (p. 55).

Slow synchronization and motion blurs: Both exposures were taken with ⇨ the N90/F90 camera and a AF-D zoom Nikkor lens (28-70mm f/3.5 - 4.5) in programmed automatic mode. The picture on top was taken without flash; the slow shutter speed of approximately 2 seconds blurred the relatively dark motion streaks so that only the light center of the carnival ride is visible. The use of slow synchronization, "SLOW" and second shutter curtain "REAR" sync in the bottom photo, resulted in very pleasing, life-like superimposition of the sharp flash image and the blurred motion effect.

Cameras with TTL flash capability: In cameras which are already equipped with dedicated TTL flash, the shutter speed of the camera is adjusted automatically to the flash sync speed when "A" mode is used. Other than that you should follow the procedure described above.

Using N8008/F-801, F4, and N90/F90 cameras: The ISO film speed and zoom head are automatically adjusted in these cameras. The flash sync speed may be selected freely up to 1/250 sec.

❐ Adjust the camera for manual exposure and select an appropriate flash sync speed up to 1/250 sec. You can also use aperture priority and the camera will select a proper sync speed.

❐ In aperture priority automatic, make sure the lens aperture and the flash's LCD readout for aperture match.

❐ In manual mode adjust the aperture opening on the lens until the distance set on the camera corresponds with the distance range indicated on the flash unit's LCD.

❐ Focus on your subject and shoot.

When to Use Non-TTL Automatic Flash "A?"

Generally inferior to manual or TTL autoflash modes: In complex cases a precisely adjusted manual flash exposure is better than non-TTL automatic flash. Also, because the measured angle remains the same (the flash sensor in "A" mode is not matched to the angle of coverage of the lens) and the controllable range is smaller, it is generally inferior to TTL autoflash modes.

Motion effect with slow sync: Both pictures were taken with the N90/F90 camera and an AF-D Nikkor lens. Top: Programmed autoflash is used at f/4 and 1/60 sec. Bottom: Aperture priority mode is used with f/5.6 at 1/4 sec. (with slow synchronization, "SLOW"). Due to the retention of detail along with the motion effect and the warmer color tones (the light of the incandescent lamp is more noticeable), the picture at the bottom is much more successful in conveying the "impression" of a potter's wheel in action.

When "A" mode is the best alternative: Whenever "grabbing the shot" is a higher priority than absolutely perfect exposures and the camera does not feature TTL autoflash, non-TTL automatic flash "A" should be the method of choice. The advantage of the SB-25 over other automatic flash units (depending on the film sensitivity) is an aperture range of up to 6 steps and a distance range of 2 to 66 feet (0.6m to 20m).

Standard TTL Autoflash "TTL"

Principle
After triggering the shutter release, light reflected off the film during the flash exposure is measured (with a slight emphasis on the center) by a sensor in the bottom of the camera. The duration of the flash is adjusted to achieve a middle-value exposure. Unlike TTL auto fill-flash mode, there is no automatic adjustment of the flash duration (or as Nikon prefers, no automatic "compensation"). Additional information is provided in the main chapter, "The Basics of Flash Technology." Handling is relatively simple; the photographer preselects an aperture appropriate for the distance range.

Suitable Cameras and Lenses
For almost all current Nikon cameras: The SB-25 can be used with standard TTL autoflash with almost all Nikon cameras featuring TTL flash control. An exception is the F3 camera which has the TTL flash option only when used with certain "F3 flash units." Depending on the camera model, TTL autoflash can be combined with manual or automatic camera exposure modes. TTL autoflash can be used with practically all lenses.

With recent Nikon cameras: With the N8008/F-801, N6006/F-601, N6000/F-601M and N90/F90 cameras automatic balanced fill flash (TTL) is available with matrix, center-weighted or spot ambient metering when using an AF or AI-P lens. When using NON-AF lenses automatic fill-flash (TTL) is only available with center-weighted and spot metering since matrix metering is not available with these lenses, whether using flash or not. On the SB-25 in these cases, if the person/sun symbol or the matrix-like symbol appears on the LCD panel, then the camera is auto-

matically compensating the flash output to slightly underexpose for a more natural looking result. If neither of these symbols is present, then the auto compensation is cancelled and the flash is in "standard TTL." The flash output will be controlled for a correct, but not reduced, exposure. In either case, balanced fill or standard TTL, the camera's ambient meter will have selected a correct exposure for the available light. (The choice between fill or standard is selected on the N6006 and N6000 camera body instead of the flash. But in a similar manner, when the symbol is displayed in the camera's readout, you get fill; when it is invisible, you get standard TTL.)

With the N5005/F-401x: With this camera the SB-25 will always attempt fill-flash; there is no way for the user to change to standard TTL. The choice between matrix and center-weighted ambient meters is based on the camera exposure mode: program, aperture and shutter priority operate <u>only</u> in matrix metering. Using the AE-L button in any auto exposure mode (P, A, or S) activates center-weighted metering. Manual exposure mode always uses center-weighted metering.

With the Nikon F4: Automatic balanced fill-flash is available with matrix or center-weighted ambient metering with any AF, AI-P, or AI/AI-S lens. Older lenses with AI conversion will not work in matrix metering, thus matrix balanced fill-flash is not available. Only center-weighted fill-flash will work with AI converted lenses. Spot metering is not available for fill-flash. When activating the spot meter, the camera automatically changes the flash to standard TTL, cancelling the auto compensation feature of automatic balanced fill flash.

Note: When any camera/SB-25 flash combination is set for auto fill-flash, there will be times when light levels or operating conditions do not allow adequate ambient light exposure. In those cases, the camera "knows" that it is getting insufficient available light. Rather than reducing the flash exposure for fill-flash (thus, creating an underexposed image) the camera defaults to a standard TTL flash exposure, even though set for fill-flash.

TTL

ISO *100*

0.6 0.8 1 1.5 2 3 4 6 9 13 18 m

ZOOM *35* mm *F5.6*

Procedure

❑ Mount the SB-25 to the camera accessory shoe and turn on camera and flash.

❑ Set the correct film speed on the SB-25.

❑ Set the SB-25 on "TTL" mode.

❑ Set the SB-25's zoom head to match the focal length of the lens if this does not occur automatically.

❑ Select any exposure mode on the camera.

❑ If necessary, set the camera to flash sync speed. (F4, N8008/F-801, N90/F90 cameras below.)

❑ Focus on your subject.

❑ If "M" or "A" camera exposure mode is used, select the desired aperture on the camera lens.

❑ Set this aperture on the LCD of the SB-25 and check whether the displayed distance range matches the focused distance on the lens.

❑ If necessary, adjust the aperture on the lens and on the flash unit until it correlates with the distance range.

❑ All you need to do now is press the shutter release.

❑ For flash controls, see "Flash Controls" (p.55).

Older cameras using programmed autoflash modes: When programmed autoflash modes are used, the camera selects a fixed flash sync speed and, depending on the camera model, a fixed aperture (or the latter is varied automatically as a function of ambient light measurement).

When to Use Standard TTL Autoflash?

In complex lighting conditions a precisely adjusted fully manual

flash exposure may be better than a standard TTL autoflash exposure. This is because the absence of a monitor preflash makes standard TTL flash inferior to the auto fill-flash modes, in particular, those using matrix-metering.

Cameras without advanced TTL autoflash capability: In this situation, standard TTL autoflash will be used if the camera does not offer another choice.

Fill-flash with older "classic" cameras: With targeted manual exposure adjustment for ambient light and compensation affecting only the flash, even older cameras such as the N2000/F-301, N2020/F-501, FA, etc. are capable of acceptable fill-flash exposures. For minus corrections, simply set the ISO film speed higher than the one actually in use!

Center-Weighted TTL Automatic Fill-Flash

Principle

This automatic mode in its simplest form merely represents an automatically determined flash compensation. Ambient light is measured using a center-weighted bias. However, the background is generally not given enough emphasis or consideration. Advanced auto fill-flash systems more accurately account for ambient light or the brightness of the background (see the chapter on matrix-controlled auto fill-flash). For additional information regarding this method see the main chapter, "The Basics of Flash Technology" (p. 122).

Suitable Cameras and Lenses
For N5005/F-401x, N6006/F-601, N8008/F801, F4, and N90/F90 cameras: When AF or AI-P Nikkor lenses are used, these cameras, as a rule, work with matrix-balanced TTL auto fill-flash. N6006/F-601, N8008s/F-801s, and N90/F90 cameras allow optional switching between center-weighted or spot ambient metering with TTL auto fill-flash. (The F4 is only capable of auto fill-flash in the center-weighted metering mode.) The N5005/F-401x only uses center-weighted metering in automatic exposure mode when the AE-L button is activated. When NON-AF Nikkor lenses are used,

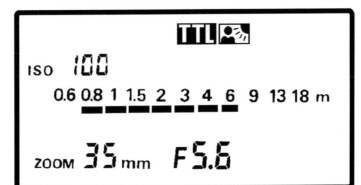

ISO 100

0.6 0.8 1 1.5 2 3 4 6 9 13 18 m

ZOOM 35 mm F5.6

Liquid crystal display (LCD) using TTL auto fill-flash. The fill-flash symbol appears whenever automatic fill-flash is used with TTL flash control. This slightly reduces the flash exposure but does not affect the camera's ambient metering system (center-weighted, spot, or matrix).

these cameras switch automatically to "A," automatic aperture priority with center-weighted automatic fill-flash. In this case, the SB-25 displays the TTL symbol without the additional fill-flash or matrix symbol.

Procedure

❒ When NON AF and Al-P Nikkor lenses are used, N6006/F-601, N8008/F-801, F4, and N90/F90 cameras can be set on TTL auto fill-flash only with center-weighted camera metering.

❒ Otherwise follow the same procedure as described in the last chapter "Standard TTL Autoflash Exposures."

When to Use Center-Weighted TTL Auto Fill-Flash?

This mode makes it possible to use auto fill-flash when NON-AF lenses are used on newer Nikon cameras. It is sometimes an appropriate choice, though, even with an AF lens. If the central portion is the primary concern for exposure with the background being totally unimportant, select this method to control the exposure of this important area. In order to obtain the best possible results, center-weighted TTL auto fill-flash mode is best used with the camera set for manual exposure. However, for quick operation, select "P," "S," or "A" and selectively meter an area that is of middle-value, press and hold the AE-L (auto exposure lock), then

recompose and shoot. You can also do this with spot metering if a highly selective area is desired.

Spot TTL Auto Fill-Flash
Principally, the same applies here as for center-weighted TTL auto fill-flash mode (above). If targeting exposure for a specific area using AE-L, it is important to select an area that is of middle value (18% gray). For additional information read the chapter, "The Basics of Flash Technology" (p. 122).

Matrix-Balanced Fill-Flash

Principle
This flash mode automatically considers ambient light (and in the case of back-lit subjects, the contrast relative to the background brightness) based on matrix metering. This is done before the actual flash exposure. The auto system sets the flash sync speed and aperture appropriate for the ambient light. The TTL sensor controls the flash during the exposure based on a slightly center-weighted evaluation. When the shutter is released, a precise adjustment takes place based on the TTL-sensor which monitors the actual exposure.

Suitable Cameras and Lenses
N5005/F-401x, N6006/F-601, N8008/F-801, F4, and N90/F90 with AF and AI-P Nikkor lenses: With AF or AI-P Nikkor lenses, these cameras work with matrix metering when set on program, shutter or aperture priority with matrix-balanced TTL fill-flash. Manual camera exposure mode can be used, however, the background or ambient light must be adjusted manually in a very specific manner. Optionally, N6006/F-601, N8008s/F-801s and N90/F90 cameras can also be used with center-weighted or spot TTL auto fill-flash mode. The F4 can only be used with center-weighted fill-flash mode.

Procedure
❑ Mount the SB-25 in the camera accessory shoe and turn on both the camera and the flash.
❑ Set the SB-25 on "TTL" mode.

❐ Depending on the camera model, the SB-25 displays the TTL symbol with the fill-flash or matrix symbol.
❐ If necessary set the film speed and the zoom head.
❐ Aperture values are automatically transferred to the SB-25.
❐ Select an automatic exposure mode or manual exposure setting.
❐ With manual exposure or shutter priority, a flash synchronization speed up to 1/250 sec. can be selected
❐ Focus on your subject.
❐ Check whether the distance range displayed by the flash unit's LCD is appropriate for the distance to the subject. If necessary, adjust the aperture on the lens (or first the automatic mode) until it is appropriate for the indicated distance range.
❐ Now, press the shutter release.
❐ For further information see, "Flash Controls" (p. 55).

When to Use Matrix-Balanced Fill-Flash?
The best flash method with N5005/F-401x, N6006/F-601, N8008/F-801, and F4 cameras: For normal photography, I cannot think of a better flash method than matrix metering with automatic exposure. With the N90/F90 camera and AF and AF-P Nikkor lenses, the SB-25 provides improved auto fill-flash plus additional monitor preflash and TTL multisensor metering. With the use of AF-D Nikkor lenses, the N90/F90 camera automatically activates a 3D matrix for control. A more detailed explanation of these advanced automatic flash modes will be provided in the following section.

Caution with difficult subjects: Subjects exhibiting extremes of reflectance or lack of reflectance (black on black or white on white) or subjects which are off-center, could pose problems. In these cases manual metering and manual flash exposure with additional adjustments may yield better results.

Backlit exposures: If you photograph a person in front of a light background using matrix metering standard TTL flash without fill-flash, the main subject usually appears lighter than the background. Pictures taken with automatic exposure compensation are frequently still too dark or the background is unnaturally light

and the colors of the main subject are not well-saturated due to excessive illumination. In contrast, by using automatic fill-flash, not only are the subject's colors saturated and luminous but also the background is rendered at a normal brightness level.

Avoiding over-exposure of surrounding images: Often in flash photography a pleasant mood can be created if the surrounding area is not over-exposed by the flash. This over-exposure can be prevented by using auto fill-flash mode; the reason this works is that you have brightened the image in a subtle manner by combining a relatively high exposure (large aperture and relatively slow shutter speed) with a low-power flash (automatic minus-correction).

TTL Multi-Sensor Auto Fill-Flash

Principle

As in "normal" matrix-balanced TTL fill-flash mode, the aperture, shutter speed, and duration of the flash are preliminarily adjusted before the shutter release is pressed. This is based on a measurement of ambient light and possibly subject contrast.

Liquid crystal display (LCD) using TTL multisensor auto fill-flash mode. The matrix symbol appears only with the use of an N90/F90 camera and AF lenses. This does not affect the camera's ambient exposure metering method (center-weighted, spot, or matrix).

During the actual flash exposure, TTL-control is based on a five-segment multisensor metering system. This multiple-segment flash measurement is independent of the preliminary method of exposure calculation which was used before the shutter release was actually pressed. Hence, extremes in subject reflectance are compensated for particularly well.

Suitable Cameras and Lenses
Presently <u>only</u> the N90/F90 camera can be used, and <u>only</u> with AF, AF-D, or Al-P Nikkor lenses.

Procedure
(See matrix-balanced auto fill-flash mode.)

When to Use TTL Multi-Sensor Auto Fill-Flash?
With the N90/F90 camera and appropriate lenses, this mode is ideal for all subjects and situations.

TTL-Multi-Sensor Auto Fill-Flash with Monitor Preflash

Principle
When the camera release is depressed all the way, the SB-25 sends out a series of invisible measuring flashes (preflashes) which are evaluated by the multisensor. This feeds information concerning spatial distribution and the reflectance of the main subject and background to the automatic flash system so that an accurate adjustment of the duration of the flash may be made.

Suitable Cameras and Lenses
Presently this works <u>only</u> with N90/F90 camera with AF or Al-P Nikkor lenses and the SB-25 flash unit.

Procedure
❏ The monitor preflash is automatically activated when AF, Al-P, and AF-D Nikkor lenses are used!
 Please note: For monitor preflash to be activated, the flash head must be in the normal forward position. If the head is bounced, swiveled or tilted, the automatic preflash will be cancelled.

❐ Otherwise proceed as above for matrix-balanced auto fill-flash.

When to Use Monitor Preflash?
With the N90/F90 camera and the SB-25 flash (if the appropriate lenses are available) use preflash for all subjects and situations because this can only result in an improved image.

3D-Matrix TTL Multi-Sensor Auto Fill-Flash

Principle
In this case the use of AF Nikkor type D lenses activates an additional distance adjustment relative to the main subject. (See "The Basics of Flash Technology" p. 122).

Suitable Cameras and Lenses
This mode is available <u>only</u> when the N90/F90 camera is used with AF Nikkor type D lenses and the SB-25 flash unit.

Procedure
❐ The 3D matrix is activated automatically when AF-D Nikkor lenses are used!
❐ Otherwise proceed as with matrix-balanced auto fill-flash.

When to Use 3D-Matrix TTL Auto Fill-Flash?
With the N90/F90 camera and the SB-25 flash, if the appropriate lenses are available, use it for all subjects and situations because this can only result in an improved image.

Exposure Metering Methods with TTL Auto Fill-Flash

Camera metering method only affects ambient light: When using TTL auto fill-flash mode, the selected camera metering method with the N5005/F-401x, N6006/F-601, N8008/F-801, F4, and N90/F90 cameras affects only the ambient light measurement. The TTL flash is controlled independently in a slightly center-biased integral manner. With an N90/F90 camera and AF Nikkor D-type lenses, a multisensor evaluation is performed, integrating additional distance information.

Matrix metering of ambient light: Matrix metering gives optimal consideration to ambient light and subject contrast. If automatic flash mode is used, this is the recommended metering method. However, it is available only with AF, AI-P and AF-D Nikkor lenses (except with the F4 which can also use AI/AI-S lenses).

Center-weighted metering of ambient light: In this case ambient light is measured only in relation to middle (18%) gray and contrast is basically not considered. This method is recommended for use with NON-AF lenses or when selective control of exposure values in the center area of the image is desired (or in other areas by pre-metering and recomposing).

Spot metering of ambient light: This is recommended for metering very specific areas in order to establish a particular ambient light exposure value in reference to middle or 18% gray.

TTL Flash with Programmed Autoflash Camera Mode

In programmed autoflash mode the camera selects the aperture and shutter speed automatically. The selected flash mode and camera metering method determines how the camera interacts with the SB-25 and the quality of the end result.

Suitable Cameras and Flash Methods
Ideal with matrix metering: In this case the aperture and the shutter speed will be automatically preselected as a function of the ambient light and the subject contrast.

Suitable cameras: Programmed autoflash or TTL auto fill-flash is only recommended in conjunction with N5005/F-401x, N6006/ F-601, N8008/F-801, F4, and N90/F90 cameras. *With AF and AI-P Nikkor lenses only:* Programmed autoflash is useful only with CPU lenses such as AI-P, AF, and AF-D Nikkor lenses.

With older cameras: Most do not have advanced autoflash mode; in standard "programmed flash" the camera is set on a fixed flash sync speed and, depending on the camera, a fixed aperture is selected.

Procedure
Simply set the camera on "P" and the metering on "matrix." See also,"Matrix-Balanced Fill-Flash" (p. 73).

When to Use TTL Flash with Programmed Autoflash?
First choice: With matrix-balanced programmed flash this method would normally be the first choice. There is hardly anything faster and the method is highly likely to be successful.

Limits of programmed autoflash mode: If you want to select specific shutter speeds or apertures for special image effects, other exposure modes offer more flexibility. In program mode the camera will choose aperture and shutter speed automatically, limiting the shutter speed for "Normal" flash between 1/250 and 1/60 (1/250 and 30 seconds in N90/F90, N6006/F-601 and N6000/F601M). ("Rear" flash is normally slow sync.) The aperture will then be selected based on the sync speed. In equivalent lighting conditions as the ISO film speed increases, the aperture the camera will select will decrease.

Advantages of aperture priority: If you want to be able to select specific apertures for depth of field, you should use auto aperture priority.

Advantages of shutter priority: If you specifically want the motion-blur effect available with slow synchronization, use shutter priority auto. The camera automatically selects an aperture to give the best possible ambient light exposure.

Advantages of manual exposure adjustment: If you want a lighter or darker background in fill-flash mode, you should work with manual exposure adjustment.

TTL Flash with Aperture Priority Auto Camera Mode

By using the camera in aperture priority camera mode "A," you can preselect the aperture which allows you to control depth of field.

Suitable Cameras and Flash Methods
Older cameras: TTL flash with aperture priority automatic can be used with all Nikon cameras which feature TTL autoflash (except the F3!).

Modern cameras: With cameras featuring matrix metering such as the N5005/F-401x, N6006/F-601, N8008/F-801, F4, and N90/F90, aperture priority should be used primarily for artistic control.

Matrix metering with aperture priority: Only lenses with CPUs such as AI-P, AF, and AF-D Nikkor are suitable. (Except for the F4 which also works with AI and AI-S lenses.)

Procedure
- ❐ Set your camera on "A" and the SB-25 on "TTL".
- ❐ In older cameras the shutter speed is automatically set to a fixed sync speed; in modern cameras a sync speed is automatically selected based on ambient light conditions.
- ❐ Select the desired aperture on the lens.
- ❐ For older cameras refer to "Standard TTL Autoflash."
- ❐ For cameras with matrix metering refer to "Matrix-Balanced Fill-Flash" (p. 73).

Using TTL Flash Mode with Aperture Priority
Caution with spatially deep subjects: In TTL flash mode the aperture always affects the background brightness. An incorrect choice can result in an unnaturally light or dark background. See also sections "Spatially Deep Subjects" (p. 118) and "Controlling Back-ground Brightness" (p. 99).

TTL Flash with Shutter Priority Automatic Camera Mode

By using shutter priority automatic in conjunction with TTL autoflash mode you can select any shutter speed from the fastest available flash synchronization speed to the slowest possible shutter speed.

Suitable Cameras and Flash Methods
Older cameras: Except for the Nikon FA, older Nikon cameras do not feature shutter priority auto.

Modern cameras: With cameras which feature shutter priority capability and matrix metering (such as the N5005/F-401x, N6006/F-601, N8008/F-801, F4, and N90/F90), automatic shutter priority should mainly be used for artistic purposes.

With AF and AI-P Nikkor lenses only: Only lenses with CPUs such as AI-P, AF, and AF-D Nikkors allow shutter priority automatic.

Procedure
❐ Set your camera on "S" and the SB-25 on "TTL".
❐ The speed may be selected freely within the range from the highest available sync speed to the slowest possible shutter speed; the aperture is adjusted automatically.
❐ Otherwise see, "Matrix-Balanced Fill-Flash" (p. 73).

Using TTL Flash with Shutter Priority Automatic
Useful for motion effects: The automatic shutter priority mode is ideal for selecting shutter speeds which will enable the photographer to create blurred-motion effects (see the section, "Motion - Blur Effects" p. 103).

Risk of blur from camera shake: Camera movement causes blurred images to be superimposed on the flash image. Because this is sometimes undesirable, when using TTL fill-flash with the camera in shutter priority automatic mode you must consider this result.

Undefined depth of field: Photography of landscapes or non-

moving subjects is not enhanced by choosing shutter priority mode. This is because of the importance of depth of field. Although the aperture can be changed by adjusting the shutter speed (there is also no depth of field preview available in shutter priority since the lens is preset to the smallest aperture) it is easier to use aperture priority or manual modes.

TTL Autoflash with Manual Camera Exposure Mode

By using manual adjustment any aperture and shutter speed may be selected in conjunction with TTL autoflash. The flash is controlled with TTL-metering after its release.

Suitable Cameras and Flash Methods
Older cameras: All Nikon cameras featuring TTL autoflash may be used (except the F3). They are suitable for TTL flash mode with manual exposure adjustment and center-weighted metering. If the camera automatically sets a fixed sync speed in TTL flash mode, there will essentially be no difference when compared to aperture priority.

Modern cameras: When using cameras with matrix metering such as the N5005/F-401x, N6006/F-601, N8008/F-801, F4, and N90/F90 manual exposure adjustment should be used primarily for artistic control.

Matrix measurement with manual exposure adjustment: Only lenses with CPUs such as AI-P, AF, and AF-D Nikkor are suitable for this.

Procedure
❐ Set your camera on "M" and the SB-25 on "TTL."
❐ In older cameras the shutter speed may be set automatically to a fixed synchronization speed.
❐ In modern cameras select a speed between the fastest possible sync speed and the slowest shutter speed. (For spot and center-weighted metering, read the part of your subject where the flash exposure will be the most predominant.)
❐ Use the aperture ring on the lens to select the desired aperture.

❏ For older cameras refer to "Standard TTL Autoflash Mode."
❏ For cameras with matrix metering see "Matrix-Balanced Auto Fill-Flash" (p. 73).

When to use TTL Flash with Manual Exposure Mode?
For specific adaptation to ambient light: In most cases, the brightness of the foreground and that of the background may be adjusted as desired.

Modern cameras: With manual exposure adjustment on modern cameras there is no need to totally rely on automatic fill-flash. On the other hand, some skill is required and precious time may have to be spent in order to gain an improvement over the automatic setting.

Camera and Flash Exposure Compensation in TTL Mode

Note carefully: Because the duration of the flash may be adjusted independent of the camera exposure, a distinction must always be made between "flash exposure compensation" and "camera exposure compensation."

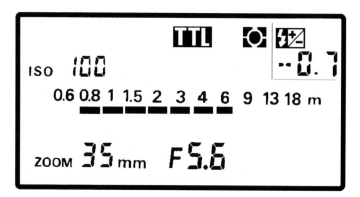

Liquid crystal display (LCD) using TTL multisensor auto fill-flash mode with manual flash compensation of -2/3 (.7) f/stop. Depending on the camera, multisensor or normal TTL auto fill-flash mode may be used.

Exposure Compensation

Adjustments affecting the entire exposure: By changing the ISO setting or the exposure compensation dial on the camera body, the entire exposure (aperture, shutter speed and flash duration) will be affected in all TTL autoflash modes. This means the image foreground and background will become lighter or darker. However, care must be taken since a change in the film speed also results in a change of the guide number, and therefore the shooting range. (See "The Basics of Flash Technology" p. 122.)

Exposure compensations affecting only the flash: Flash exposure adjustments, also called "flash compensation," are made on the LCD of the flash, with the flash compensation lever on the N6006 and N6000, or with the MF26 back on the N90/F90. These changes cause a variation of the duration of the flash which is independent of the camera's selection of aperture and shutter speed. The foreground brightness change (from flash compensation) is different from that of the background.

Manual Flash Exposure Compensation

Modern cameras: A manual flash compensation adjustment may be made instead of the automatic compensation selected by fill-flash mode. Turn off auto compensation by pressing the "M" button and confirming that the Person/Sun or Matrix-like icon disappears from the flash panel. As with automatic compensation, manual adjustment affects only the duration of the flash and not the overall exposure. The method of activation varies slightly from one camera model to the next.

N8008/F-801, F4, and N90/F90 cameras: Adjustments may be made on the SB-25 within a range of +1 EV and -3 EV. Turn off auto compensation as stated above. Then press "SEL" and use the arrow keys to select the amount of compensation desired in 1/3 f/stop increments.

N6006/F-601: The flash function button on the camera is used for flash compensation.

N90/F-90 only: Using the Multi Control Back MF-26, a manual flash correction may be stored as a retrievable value. The MF-26

can also be used to control compensation values for speedlights that, unlike the SB-24 and SB-25, do not have built-in, user-selectable, manual compensation levels.

Automatic Compensation
Bracketing with the N90/F90 and MF-26: Using the Multi Control Back MF-26 in the flash bracketing mode, a series of exposures in predetermined steps (of 0.3 to 2.0) can be made. This exposure compensation affects only the flash exposure. With automatic flash bracketing, a series of exposures is made by changing the flash duration in increments selected by the user. This last option is possible only when using the MF-26.

Using exposure compensation in TTL flash mode:
For experts only: It takes a lot of knowledge and experience to produce results which are superior to the automatic flash adjustments made in auto fill-flash mode. Therefore, proceed carefully and be prepared to waste a lot of film while acquiring the expertise. I advise you to systematically, step-by-step, practice the art of advanced flash techniques by shooting many test exposures.

Limitations of Autoflash Photography

Exposure Electronics
Limitations of metering ambient light: The limits of metering ambient light prior to the actual flash exposure are those inherent in matrix, center-weighted or spot metering.

Limits of TTL flash: Fine adjustment of the flash's output by TTL metering during the flash exposure can have time limitations. First of all, a small amount of time is required for the TTL metering cells to respond, the electronics of the camera to evaluate, and the flash unit to send the shut-off signal. Even the SB-25's switching transistor requires some time. In combination with the SB-25, the last item is probably the least restrictive, cameras are much more critical.

Film Sensitivity Range

Problem: TTL autoflash modes may be used only with film sensitivities of ISO 25 through (depending on the camera) ISO 400, or ISO 1600. If a higher film speed is used, some situations, such as close-ups may exceed the camera's response range. If a lower film sensitivity is used, at least the close-up range will be applicable as stated. This may be tested easily by using your camera with the SB-25 (see "Slide Duplication" p. 113). It is generally recommended that you stay within the film sensitivity range of the equipment.

Film sensitivity range with exposure corrections: When exposure corrections are made (with the exposure compensation dial on the camera) which affect the entire exposure, the effect of setting a different film sensitivity or ISO, is created. Theoretically, this means that the range of exposure compensation values is limited to those that will not exceed the useable ISO sensitivity range.

Color effects in TTL multiflash mode: Two graphically interesting flash ⇨ photos made with different color filters. An N90/F90 camera was used with an SB-25 and an SB-23 flash. Note: The TTL metering sensor is calibrated for "white" light and may require exposure compensation when monochromatic light is used.

Figure on the next page ⇨⇨
Slow synchronization against a dark background: Top: This flash exposure was taken with an N90/F90 camera and an AF-D Nikkor lens using programmed autoflash and normal synchronization at f/5.6 and at 1/60 sec. This technique resulted in an unnaturally dark background. Bottom: By switching the N90/F90 to "SLOW" an exposure was made at a speed of 1/4 sec. This resulted in a lighter background rendition. The blurred appearance of the foreground superimposed on the flash image is just noticeable.

Figure following the next page ⇨⇨
Normal main subject surrounded by an area of high and low reflectance: These pictures were taken with an N90/F90 camera and an AF-D Nikkor lens. The 3D matrix-controlled TTL multisensor auto fill-flash works well in spite of the relatively tiny main subject and the unusual reflectance of the surroundings. In both cases an exposure with no correction is acceptable. The best exposure of the main subject was obtained with exposure corrections of approximately -0.7 with black surroundings and +0.7 with white surroundings.

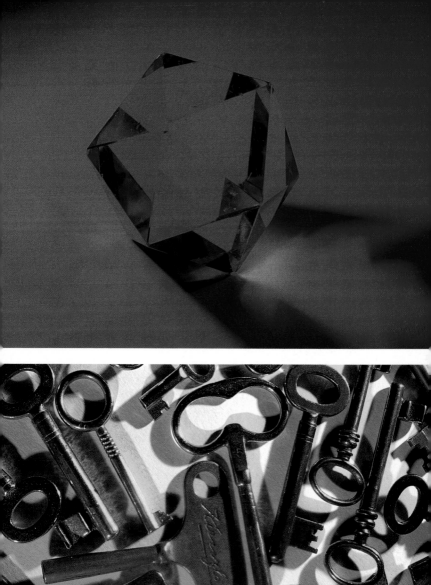

-2

-1,3

-0,7

±0

±0

+0,7

+1,3

+2

A

B

C

D

E

F

G

H

(For example, you could not make a -2 EV compensation with ISO 25 film, the lowest sensitivity limit.) If in doubt, refer to your camera instruction manual or test this situation first with your camera.

Distance and Aperture Choices

The combination of the power output of the flash unit, the film speed, and the subject distance usually permit only a limited number of aperture choices for perfect operation of TTL autoflash mode. See, "Specifications" (p. 28) for more detailed information.

Over- and Under-Exposure

Risk of over-exposure: This can occur even with TTL-controlled flash exposures when the distance from the subject is extremely short as in macro or close-up photography. (See also the section "Macro-Photography" p. 115.)

Solution: Select a smaller aperture opening in either aperture priority or manual exposure mode. Also, a neutral density filter can be attached to front of the flash unit. In an emergency transparent paper or standard white typewriter paper may be used to reduce the flash output. Another alternative is choosing a less sensitive film (lower ISO number) or setting the zoom head to a wider position, thus spreading and diffusing the light.

Autoflash comparison: This test utilized variations in size and position of the main subject against a dark background to illustrate the result of using different cameras and flash methods with the SB-25 flash. The N90/F90 camera with 3D-multisensor auto fill-flash with a type-D AF Nikkor lens yields good results with well-exposed skin tones (top). In this case, so did the N90/F90's 3D autoflash with a normal AF Nikkor lens (second row); the N8008/F-801's TTL matrix auto fill-flash without multisensor (third row) resulted in washed-out skin tones. The N2000/F-301's conventional TTL autoflash (fourth row) also produced over-exposed skin-tones.

Risk of under-exposure: This occurs when the distance to the subject is so great that the maximum amount of light emitted by the flash unit is inadequate. The maximum range of the flash, which is less with small lens apertures (high f/stop number) and greater with larger aperture openings (low f/stop number), corresponds to the range of the flash unit in "manual" mode. Even the best auto-flash unit cannot deliver more than "full output."

Solution: If the power output of the flash is insufficient, move closer to the subject, use a more sensitive film (higher ISO number), or increase the aperture opening (in aperture priority or manual camera modes).

Objects or Scenes with Unusual Reflectance
Black-on-black and white-on-white: Problems may arise when flash exposures are taken of subjects that are extremely reflective or non-reflective. A bride dressed in white in front of a white wall, for example, will appear too dark in the finished photo, or a black cat in the shade of a black car will appear too light. In these types of situations, one solution is to set the flash unit and the camera on manual flash mode. After taking a series of bracketed exposures you should have at least one excellent shot. This can also be done in TTL, using exposure compensation to "bracket" flash duration by shifting from an assumed middle-value exposure to "over-expose" a highly reflective subject or "under-expose" a dark subject. This has the added benefit of maintaining a single working aperture, thus consistent depth of field. The MF-26 can also be used in a similar manner in the flash bracketing mode.

The N90/F90's autoflash can handle even unusual subjects: Until now a subject exhibiting unusual reflectance could not always be handled well with automatic flash. Thanks to TTL multisensor control featured on the N90/F90 camera with AF lenses, even "standard" flash units can cope with these subjects much better than conventional cameras. The flash exposure can be even more precise with monitor preflash offered on the SB-25 and by using type D, AF Nikkor lenses. In these situations the N90/F90 camera and SB-25 with 3D autoflash will give "studio-quality" results.

Flash Effects with Unusual Synchronization Speeds

If your camera has the appropriate features, a number of interesting effects can be attained by choosing unusual synchronization speeds.

Slow Synchronization
This is a good way of taking into consideration existing ambient light or background brightness. Slow sync can be used to lighten the background or to superimpose out-of-focus moving subjects on the sharp flash image (see also "Flash Methods for Special Applications" p. 98).

Older cameras: In manual camera mode, shutter speeds which are slower than typical flash synchronization speeds may be selected for use with any flash exposure mode (including TTL mode, if available).

Modern cameras: With cameras such as the N6006/F-601, N8008/F-801, F4, and N90/F90 manual exposure and shutter priority auto can be used to select slower shutter speeds in flash mode.

"SLOW" sync function: When flash exposures are made using the autoflash functions "P" and "A", the N6006/F-601 and the N90/F90 feature an automatic selection of shutter speeds slower than1/60 - 1/15 sec. (depending on the lens in use.) This occurs in "SLOW" mode which is set on the camera.

"REAR" synchronization with the second shutter curtain: With "Normal" synchronization (with the first shutter curtain) the moving subject will "push" its motion blur in front of the sharp image. This occurs because the sharp flash exposure occurred at the beginning of the movement. With second curtain or REAR sync, the flash fires just before the shutter closes causing the sharp subject to "drag" its motion blur. This corresponds with the natural way we perceive motion.

"REAR" on N8008/F-801, F4, and N90/F90 cameras: "REAR" must be selected on the SB-25.

"REAR" on the N6006/F-601: Adjustment must be set on the camera; this overrides the setting on the SB-25.

Older cameras: Cameras which have not been mentioned above do not allow the "REAR" function. Therefore, the switch on the SB-25 should always be set on "NORMAL."

"FP" High-Speed Flash Synchronization
With the N90/F90 only: With the SB-25, the N90/F90 camera permits the use of flash sync speeds up to 1/4000 sec. At last, faster moving subjects can be "frozen" with fill-flash (see the section, "Freezing the Action" p. 104).

TTL-Controlled Multiple Flash Photography

Suitable Cameras and Flash Units
Principle: The camera, the main flash unit, and auxiliary flash units are connected with each other using TTL cords and adapters. All flash units are TTL-controlled by the camera. With a little experience, backgrounds can be lightened, intriguing backlit exposures can be simulated, and much more. Extremely poor exposures are almost impossible thanks to TTL autoflash.

Suitable cameras: With the SB-25, all Nikon cameras with TTL autoflash (except the F3) allow the simultaneous control of several TTL flash units.

Suitable flash units: Only original Nikon TTL system flash units (see also the operating instructions of each flash unit) should be used for multiple flash exposures.

Combining flash units from other manufacturers is not recommended: When other brand flash units are used, not only is it possible that errors may result, but also your camera and flash units may be damaged! Nikon-compatible flash units from another manufacturer should be used only if this manufacturer assures that these concerns are unwarranted.

Accessories for TTL Multiflash

Relatively few accessories are required. In addition to the flash units themselves, you need one or more distribution units (TTL Multiflash Adapter AS-10), a remote cord (TTL Remote Cord SC-17), and a few connecting cords (TTL Multiflash Sync Cords SC-18 or SC-19). If you mount the SB-25 directly on the camera, you do not need the SC-17 because the SB-25 has a built-in TTL Multiflash terminal. On the other hand, an SC-17 cord is always handy to have for taking off-camera flash pictures or when using a flash bracket.

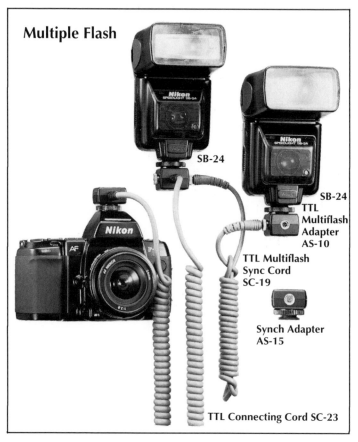

Multiple Flash

SB-24

SB-24
TTL
Multiflash
Adapter
AS-10

TTL Multiflash
Sync Cord
SC-19

Synch Adapter
AS-15

TTL Connecting Cord SC-23

The TTL multiple-flash options shown here with an SB-24 also work with the SB-25.

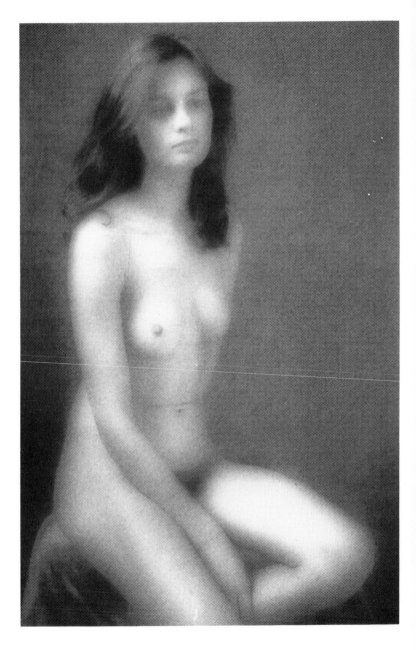

96

Recommendations for Using TTL Multiflash Mode
Number of flash units which can be combined: In order to prevent overloading of the camera's electronics a limited number of flash units can be used. To assist in determining the correct combination of units, Nikon systems flash units are assigned a "power co-efficient number." For example, the power coefficient of the SB-20 is (9), the SB-22 (6), the SB-23 (4), the SB-24 (1), and the SB-25 (1). The number of flash units connected with each other should not exceed a power coefficient total of 20. This means, for example, that you may connect one SB-25 + two SB-20's, or one SB-25 + four SB-23's, or one SB-24 + one SB20 + one SB-22 + one SB-23 unit. Generally it is not recommended that you use more than five flash units regardless of the coefficient total. This is because more than five units pointed at the same subject may cause an increase in exposure from normal. This is due to residual exposure which is accumulated as the duration of the exposure is controlled (the light output is not OFF instantly). If more than five flash units must be used, they should not add up to a coefficient total over 20, and they should either not be pointed at the same area or testing should be done to determine any necessary exposure compensation.

Overload
If too many flash units are connected with each other, the camera and/or flash units may not fire. To "reset," the main flash unit must be switched off and removed from the camera. Then each flash unit should be switched on and off at least once. Of course, if necessary, fewer units should be used or the combination should be rechecked by referring to the coefficient numbers above.

Softening the effect of the flash with a diffuser card and a "grainy" soft-focus filter resulted in this pleasing example of nude photography. Photograph: Wolf Huber.

Flash Methods for Special Applications

Flash Exposures in Low Light or Darkness

"Black Holes" in Deep Subjects

Problem: Since the light released by the flash decreases in proportion to the square of the distance, the area between the foreground and the background frequently becomes a "black hole."

Flash exposures with slow shutter speeds: The "black hole" situation occurs typically in larger, poorly-illuminated rooms. If there is noticeable ambient light and the subjects are not moving, this situation can be handled by using a slower shutter speed. Unlike the choice of aperture, which affects the flash-exposed foreground, the choice of shutter speed affects only the ambient light (and therefore, the background) exposure.

For almost all cameras: By using manual exposure adjustment on the camera, shutter speeds which are slower than the typical flash synchronization speed may be selected for use with flash (even with TTL flash mode).

"SLOW" sync: When an aperture appropriate for the desired depth of field has been preselected on the N90/F90 or N6006/F-601, this flash mode with matrix metering will automatically adjust the background brightness in accordance with the exposure time in aperture priority and programmed autoflash. Don't forget to use a tripod and a self-timer or cable release to prevent camera movement.

"SLOW" sync for moving subjects: Moving subjects will be blurred with low ambient light and slow shutter speeds. If this is desirable, it is better to use "SLOW" mode with shutter priority.

Multiple Flash Lighting of Spatially Deep Subjects
Use of several flash units: In order to lighten the background several flash units in addition to the camera-mounted flash can be fired either with TTL cords or with flash "slaves." However, because TTL auto fill-flash responds to the ambient light metered before the flash is fired, additional flash units may over-lighten the background. Therefore, a fully manual flash exposure determined by using a hand-held flash meter (see "Studio Flash Photography" p. 107) is recommended.

Backlighting with High Contrast and Strong Ambient Light

Balanced Exposure of Background and Foreground
Problem: When backlighting is balanced with flash, the object is for the foreground and background to exhibit similar brightness levels. With conventional TTL autoflash this is possible only through specific compensation of the background exposure, and without corresponding flash compensation the foreground could possibly appear too light. Additional information and appropriate methods are described in the chapter "Flash Methods and Applications" Below is a brief overview of the important control features available on modern cameras with matrix-balanced TTL fill-in autoflash.

Programmed autoflash is best: Whenever a noticeable amount of ambient light is present, for example, in the case of backlit exposures, an appropriate combination of aperture and shutter speed will balance the foreground and the background. The simplest fully automatic method is provided by the combination of matrix metering, program, and TTL automatic fill-flash.

Backlighting alternative - manual exposure adjustment: Manual exposure with spot or center-weighted metering of the background provides similarly good or even better results with TTL automatic fill-flash.

Controlling Background Brightness
Problem: It is not always desirable that the background and the foreground have the same brightness level resulting from fill-flash.

In order to "set-off" the main subject against the background, it may be advantageous to make the background darker or lighter. Practically all recent Nikon cameras offer this option using manual exposure adjustment in combination with TTL autoflash.

Procedure

❑ The SB-25 must be set on "TTL."

❑ Using manual camera exposure mode, first set the aperture appropriate for a shutter speed between 1/60 sec. and 1/250 sec. Meter the main subject by using either spot or center-weighted metering and then adjust the exposure as if shooting without flash.

❑ The aperture determined in this manner may be closed down approximately 2 to 3 stops to make the background distinctly darker or opened up approximately 2 to 3 stops to make the background distinctly lighter.

After some trial and error, it should be possible to achieve the desired effect on the first try. (By increasing the ISO film speed setting, cameras with conventional TTL autoflash are effectively set for a minus correction which affects only the flash.)

Caution: You must be careful not to base the ambient exposure on this "adjusted" ISO speed.

Slower shutter speeds are not useful for compensation: In manual exposure mode, shutter speeds of less than 1/60 sec. are not very helpful for exposure compensation of backlit subjects. Slow shutter speeds for exposures with little available light, however, will produce motion blurs.

Additional Adjustment of Background and Foreground Brightness

By using opposing exposure compensations on the camera v. the SB-25, the brightness values of the foreground and the background may be brought closer to each other. However, in order to arrive at reliable results a few test exposures should be made.

Artistic Control of Depth of Field

Aperture affects depth of field and background brightness: You may use TTL fill-flash with aperture priority or manual exposure to select an aperture appropriate for the desired sharpness of the background. However, this is possible only when the background is relatively close to the main subject (the distance between the camera and subject is twice as far as the distance between the subject and background). If the distance to the background is too great, light falloff will be noticeable and a change in aperture will affect not only the depth of field but also the brightness of the background.

Great depth of field with slight light decrease: If depth of field is important, preselect a small aperture opening and the main subject will be set against a focused background of similar brightness (due to TTL flash control).

Shallow depth of field with slight light decrease: Use a large aperture opening if a very short depth of field range is desired and the main subject is to be setoff against an out-of-focus background of similar brightness.

Great depth of field with substantial light decrease and little ambient light: First select an aperture appropriate for the depth of field desired and then combine it with the above described "adjustment of a light or dark background" method by adjusting the exposure time. A flower in a relatively dark forest would be offset against the dark background because the great depth of field requires a small aperture opening and generally, a shutter speed of 1/60 sec. to 1/250 sec.; however, slower shutter speeds would create a lighter background. This method is suitable only for subjects which are not moving and, in order to prevent blurred images, a tripod and a cable release or a self-timer must be used.

Normally Bright, Out-of-Focus Backgrounds
Problem: Large aperture openings are required if the main subject is to be "offset" against a relatively light background in conditions with ample ambient light, with shallow depth of field. However, normally short flash synchronization speeds up to 1/250 sec. can

result in an unnaturally light backgrounds depending on the ambient light conditions.

High-speed synchronization "FP:" Faster sync speeds of up to 1/4000 sec. are possible when the function "FP" is used on the N90/F90 camera and the SB-25.

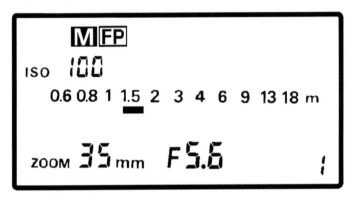

Liquid crystal display (LCD) showing the "FP" flash mode.

Procedure

❒ Set the N90/F90 camera on manual exposure and the SB-25 flash unit on main switch position "M" and use the M-button to select "FP 1" or "FP 2."

❒ Then set the aperture for the desired depth of field. The distance to the main subject as indicated on the LCD may be varied by varying the output level (FP1 or FP2) to match the subject distance or by changing the zoom head setting.

❒ Finally the background exposure is adjusted by selecting a shutter speed of up to 1/4000 sec., using spot or center-weighted metering.

Note: The N90/F90 camera and the SB-25 must operate without TTL control when set on "FP;" therefore, when the aperture has been preselected, the distance to the main subject displayed on the flash unit must be maintained <u>exactly</u>.

Motion-Blur Effects

Superimposition of Flash and Ambient Light Images
Objective: Even when using flash, motion blurs may be created intentionally. The flash image which is sharp due to the brief duration of the flash exposure is superimposed over a second, blurred available light image taken at a slow shutter speed. This can produce very interesting motion-blurs.

Creating motion blurs: For example, let's use a shutter speed setting of 1/8 sec. During the flash exposure (approximately 1/1000 sec.) the subject is "frozen" by the intense, short light of the flash. However, the subject is also illuminated additionally by normal ambient light during the entire 1/8 sec. exposure. With a moving subject, its sharp flash image will be superimposed with a second out-of-focus ambient light image. Also, if the shutter speed is slow, you can intentionally cause the blur by moving the camera. Undoubtedly, this can be a interesting field for experimentation.

Procedure
❏ Set your camera on shutter priority or manual exposure mode.
❏ Switch the SB-25 to "TTL."
❏ Preselect a slower shutter speed appropriate for the desired motion effect.

Depending on the camera model, similar effects can be attained with weak ambient light when programmed autoflash or aperture priority and "SLOW" sync are used.

Natural motion blurs with "REAR:" When using slow shutter speeds, N90/F90, F4, N8008/F-801, and N6006/F-601 cameras can be switched to "REAR" flash mode. "REAR" signifies synchronization with the second shutter curtain. In practice this means that the ambient light exposure occurs before the release of the flash. This effect is obvious only with slow shutter speeds, noticeable ambient light, and moving objects. With conventional synchronization with the first shutter curtain the object "pushes" its motion blur unnaturally in front of itself, second shutter curtain sync causes the object to "drag" the blur behind itself. Certainly the most suitable mode for slow shutter speeds is shutter priority,

or manual exposure adjustment. Incidentally, this situation often requires testing before the best results are obtained.

Freezing the Action

Problem: In the past the shutter speed range of most cameras included 1/1000 sec. as the fastest exposure time for non-blurred representation of fast-action. With high speeds up to 1/4000 sec. and 1/8000 sec. offered by modern Nikon cameras, frequently normal daylight is not adequate for high-quality action photography. Therefore, flash photography is an important method of producing good exposures.

Very Low Ambient Light with "B"
With TTL control: The camera is set to the desired aperture and the shutter speed set to "B" or "bulb" in manual camera exposure mode. (Use manual focus on AF cameras.) When a flash exposure is taken in very low ambient light or even in complete darkness in TTL mode, the moving object is recorded only during the relatively short duration of the flash. Depending on the reflectance of the object, improperly exposed images may result.

Fully manual control: This requires total darkness. (Use manual focus on AF cameras.) The camera shutter is opened for a given period of time in "B" mode by continuously pressing the shutter release or by using a locking cable release. The SB-25, set on "M," is triggered via the test flash button. Then the shutter is closed. The distance from the (preferably off-camera) flash unit to the subject was adjusted to match the selected aperture. if possible, a series of bracketed exposures should be made by increasing and decreasing the aperture setting or decreasing the manual power ratios - 1/1, 1/2, 1/4, 1/8, 1/16, 1/32, 1/64.

Reducing the flash duration to a minimum of 1/23000 sec. by varying the output: By reducing the manual flash output level in combination with a "B"-exposure (see above) flash exposures may be taken in total darkness with specific durations (see, "Specifications").

Ample Ambient Light and High-Speed Synchronization "FP"
Problem: If there is an abundance of ambient light and a fill-flash exposure is to be made of a moving subject, normal flash synchronization times will not be useful. Even at 1/250 sec. the sharp flash image is usually superimposed with a blurred, out-of-focus ambient light image. The only solution is to use high-speed synchronization "FP" (currently only with the SB-25 and N90/F90).

Procedure
❏ Set the N90/F90 camera on manual exposure mode and the SB-25 flash unit on main switch position "M" and use the M-button to select "FP1"

❏ To freeze motion a shutter speed of up to 1/4000 sec. is selected on the N90/F90 along with an aperture appropriate for the required depth of field.

❏ Because the N90/F90 and the flash unit which is set on "FP" operate without TTL control, you must maintain the exact distance from the main subject recommended on the flash unit.

❏ The distance may be changed via the output level "FP2," or by shifting the zoom head setting.

Creating Motion Sequences

Stroboscopic Flash Mode
Problem: In order to create a motion study sequence, the image must be broken down into several sharply-focused, partial images.

Operation: Using the SB-25's stroboscopic function (main selection switch) allows the firing of a sequence of several very short flashes during a normal to longer flash synchronization period. In sports and science, stroboscopic exposures permit the analysis of rapid motion. The SB-25 makes this effect possible when used with any camera with a "hot shoe."

Procedure
❏ Set the camera on manual exposure mode and select a shutter speed (if it can be varied during flash mode) appropriate for the subject. Slow shutter speeds (as slow as possible) and even

```
 M        ⚡⚡⚡

 8-10 Hz
 0.6 0.8 1 1.5  2   3   4   6   9  13 18 m
              ▬

 ZOOM 35 mm   F 5.6    M 1/ 16
```

Liquid crystal display (LCD) using stroboscopic flash mode. In this exam-
ple eight flashes with a rate of 10 shots/sec. were made.

"B" may be selected in total darkness. In this case, an out-of-
focus "ghost image" caused by continuous light will not occur.

❏ Set the flash unit's main selection switch on stroboscopic mode
(multiple flash symbol).

❏ Now you need to adjust the frequency from 1 per sec. to 1/50
per sec., the number of flashes from 1 to 160 (this is the number
Nikon states in its literature although I could only actually dial
in a maximum of 90), and a flash power output of 1/8 to 1/64.
(The combination of these selections depends on the flash out
put. For example, using 1/8 output and a flash frequency of 1
to 7 Hz, 20 flashes can be fired in a sequence; with an output
of 1/64 this means 106 flashes!)

❏ Focus on your subject (manual focus is best with AF cameras)

❏ The flash unit's LCD will display the aperture appropriate for
the distance which should be set on the lens.

If the subject is moving against a dark background with no over-
lapping exposures, this is a good starting point. If the flash bursts
overlap causing cumulative exposure in some areas, then the
aperture should be stopped down or the flash to subject distance
increased. Keep in mind that exposure recommendations are
based on optimal conditions. Test exposures or bracketing are
suggested for best results.

Studio Flash Photography

Why in the Studio and Not "On Location?"

Studio photography enables the photographer to totally control the light conditions. Also weather is never an obstacle and flash pictures taken in the studio can meet the precise lighting specifications envisioned by the photographer and the client. In practice this means that a distinction in ambient light and flash light, or in a foreground lightened by flash and a background illuminated by existing light (such as with TTL fill-flash) would be absurd in the studio.

Composing with Light

Number, intensity, and position of studio flash units: A specific light composition is attained by using several high-power studio flash units and appropriate generators. Studio-type flash photography allows the use of the most varied reflectors and luminescent surfaces (for example, bright "spot-lights" or soft "hazy-lights") and the simulation of all types of light and lighting angles ranging from bright sunlight to the soft light of a northern window. This is possible with a light output which, if desired, permits even small apertures with the use of low-sensitivity films. Because the flash duration of most studio flash units is at approximately 1/300 sec. or less, "normal" human movements are frozen and, if desired, hand-held shooting is possible (without a tripod).

Reflectors and diffusers: Reflectors (for example, reflecting panels) and diffusers (for example, diffusing screens placed between the flash and the subject) may be used in the studio to further modify the light output.

Modeling lights: In order to be able to evaluate the lighting effect, studio flash units have a built-in halogen modeling light which varies its intensity to match the previously selected flash output. This enables the photographer to make a reasonably realistic evaluation of the lighting and image effect. This is an advantage over camera-mounted flash units such as the SB-25, which leave one literally,"shooting in the dark." It is obvious that an automatic flash unit would not perform adequately in such a finely-tuned flash illumination setup. Finally, each studio flash lamp can be

assigned a different lighting effect. Camera-controlled flash cannot detect this situation. (Ideally, a properly functioning studio flash computer, would be able to do this. And rumor has it that a number of studio flash manufacturers are busily working on that.)

Manual Flash Exposure Metering
After all of the default values have been set on the flash units and generators, the camera's aperture is determined by firing test flashes. To do this, use a flash meter pointed at the subject, and again pointed in the camera's direction to measure incident light. With this reading, you have the total of all direct and indirect light hitting the subject at the time of exposure. Provided that the film sensitivity and shutter speed were correctly set on the meter, the correct aperture can be read and set directly on the camera's lens.

Flash Triggering
Cable: Studio flash set-ups can be triggered via a flash cable which is plugged into the camera's flash synch terminal. (If this is not present on your camera, use a commercially available flash shoe adapter.)

Remote Triggering: An another option might be to use a hot shoe-mounted flash unit (for example, the SB-25) and fire it indirectly at the ceiling in order to trigger the studio flash system. Most studio flash systems include a photo cells or "slaves" which will simultaneously trigger a number of units. Another more advanced method of cordless flash triggering is the use of infrared triggering devices. These are superior to visible light triggers because they are unaffected by stray light from other sources. The Wein company makes several infrared flash triggering systems that enable you to trigger multiple units at the same time. The unit attached to the camera triggers all other Wein units simultaneously. Multi-channel units even allow you to selectively trigger certain flashes independently of the others. This is by far the most elegant solution in any studio-type flash situation. For further information, contact the Wein Division of The Saunders Group (address on back cover).

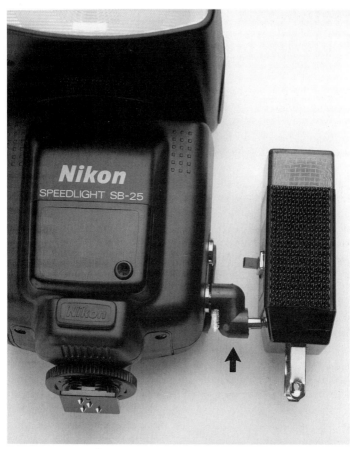

The PCM Adapter (indicated by the arrow) from Wein Products allows for cordless connection of photo slaves and remote control receivers to the SB-25's flash sync contact. In this case the PCM adapter is used to connect a Wein Pro-Sync™ infrared receiver to an SB-25. For further information contact Saunders (address on back cover).

Getting the Best Results with Any Subject

There is hardly any subject which you cannot successfully photograph with the SB-25. Obviously one SB-25 will not illuminate the nave of a cathedral, a market square at night, or a gymnasium. However, the SB-25's power output will be more than adequate for most common subjects or situations.

Nudes
Lens recommendation: As a rule, the ideal focal lengths for portraits are approximately 80mm to 105mm. Full-size close-ups of nudes may, however, require a wide angle lens. In this case care must be taken that perspective distortions inherent with the use of wide angle lenses will not be aesthetically displeasing but will enhance the total image.

Soft, diffused illumination: Generally when photographing nudes, soft, diffused light is used to prevent harsh, uneven skin tones and to prevent blemishes from showing. A diffuser in front of the flash helps in this case.

Architecture
The SB-25's high guide number is perfect for interior architectural shots.

Stroboscopic flash exposures: These exposures were taken in total darkness, against a black background with a sequence of 5 and 3 flash exposures, respectively. In areas, where several images overlap, a partial over-exposure is noticeable while other areas appear even somewhat underexposed. Therefore, trial exposures are recommended when stroboscopic flash mode is used.

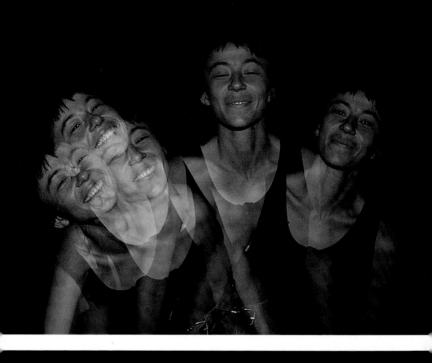

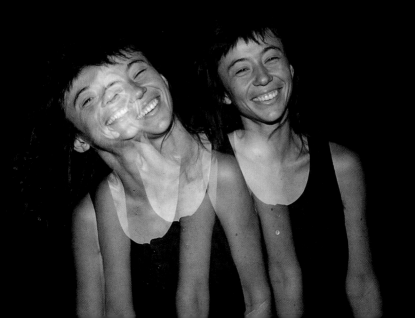

For interior spaces, use a wide-angle diffuser: Because limited space frequently requires the use of wide-angle lenses, the zoom head should be used in wide-angle position. The SB-25's 20mm diffuser panel is ideal for extreme wide-angle shots.

Optional auxiliary flash: Larger rooms with many angles may require the use of additional auxiliary or "slave" flash units which can be used to lighten distant corners. (A personal tip: Use low cost, bulb-type slaves which can be screwed directly into normal incandescent light sockets.)

Un-natural Looking Faces
In the section, "Portraits" you will find information on how to prevent excessively "washed-out" faces, rigid facial expressions, and tightly shut eyes when taking pictures of people.

Slide Duplication
Slide-duplicating devices: Slide duplication is a special application of macro-photography. Basic duplicating devices are available for less than $100.00. The only disadvantage of simple duplicating devices is that the reproduction ratio is frequently slightly greater than 1:1, meaning that some of the original image is cut off. There are two options for 1:1 duplicates: A macro-lens (such as AF Micro Nikkor, 2.8/60 mm or 2.8/105 mm) or a bellows unit with a slide-duplication attachment. The macro-lens is best used in conjunction with a copy stand with the slide placed on a light table below.

Studio-type illumination with only one flash: These exposures were taken with the N90/F90 camera and an AF-D Nikkor lens in 3D-TTL multi-sensor fill-flash mode using manual exposure adjustment (f/16 and 1/125 sec.). One SB-25 was used (diagonally from the top left front) and was at a distance of approximately 3 feet from the main subject which had a size of approximately 6 inches. The zoom head was set for 20mm (with the wide angle panel). The SB-25 was aligned with a home-made modeling light. The high-contrast picture was shot with with only one flash modifier (a white reflector, approximately 20 inches to the right of the subject). The soft-contrast picture was shot with a diffuser card and additional transparent paper positioned half-way between the SB-25 and the subject.

Slide holders are available for bellows units. Nikon, for example, has a PS-6 attachment for use with the PB-6 bellows. In addition to the bellows, a lens is required.

Films: Special Slide Duplicating Film by Kodak should be used to make slide "dupes." Like most other transparency films, it is developed with the E6 Process. Use of standard slide film, is not recommended for duplicate slides since the results will generally will have too much contrast.

Basic flash exposure control: Most slide duplicating devices work with fixed apertures of approximately f/8 to f/16. Even when using a macro-lens you should use an aperture of approximately f/8 to f/11. The basic brightness of the flash exposure can be varied in TTL flash mode, or you can use fully manual flash mode by varying the distance between the flash unit and the slide or by inserting neutral density filters (in an emergency transparent paper). With the SB-25 a distance of approximately 10 inches from the slide duplicating device is recommended.

Duplicating Slides in TTL flash mode: Flash units are excellent for use in slide duplication. Unfortunately, there is one restriction: The low sensitivity of the Kodak Slide Duplicating Film may possibly prevent the use of TTL flash control. It is probably best to take center-weighted test exposures with a film-speed setting of ISO 6, and TTL control. Vary the "basic brightness" of the flash as described above. The SB-25's LED will indicate if the exposure is not sufficient

Varying TTL flash exposure with the SB-25: Ideal for use in slide duplication (camera permitting) is compensation affecting only the flash in TTL mode. This allows you to vary the flash exposure between steps of +1 and -3. You can also use exposure compensation on the camera.

Fully manual flash exposures: Of course, the SB-25 may be adapted to your slide duplicating device by using manual flash mode and by varying the output level in a series of test exposures.

Color filters: It is recommended that you read and follow the

recommendations on the specifications sheet enclosed in the film package by Kodak. Also, generally, for best results, to fine-tune color rendition, you should use color-compensation (CC) filters.

Capturing Memories
Be it a birthday party, junior under the Christmas tree, or a service award banquet, most pictures are meant to capture memories.

Lenses: Generally, most "people-pictures" are taken from distances ranging between approximately 5 and 15 feet. Suitable lens focal lengths range between approximately 28mm and 100mm.

Recommendations: ISO 100 or ISO 200 films are always a good choice for use with the SB-25. In direct flash mode you should be careful because there may not be enough ambient light and the depth of field of the subject may decrease dramatically. Due to light fall-off, the foreground may be too light or the background too dark. Using bounce flash against a white ceiling usually works quite well. In my experience with practical applications even standard TTL autoflash provides good results. An alternative would be to use a diffuser card on the SB-25 to create a less harsh gradient and softer, more diffuse light. See also the section, "Variable Stroboframe® Flash Brackets (p. 34)."

Family: For detailed information see "Portraits" (p. 117).

Photographing Children: Photographs of children frequently appear posed or like the children were reluctantly "conned into" having their picture taken. By taking a greater number of pictures or "preliminary flash shots" the atmosphere may be relaxed. In conjunction with this, see also "Portraits" and "Red-eye."

Macro Photography with the SB-25
The tilting flash head of the SB-25 may be aligned at a downward angle of -7°. At extremely close ranges the full light cone may no longer cover the subject. This should be used for on-camera flash when the subject is within 4 - 5 feet from the camera.

Unrestricted flash exposures with TTL autoflash: True macro-photographs are best taken with the SB-25 in an off-camera

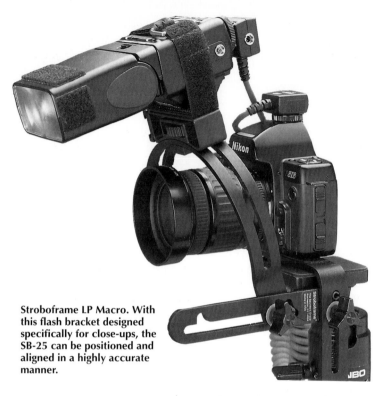

Stroboframe LP Macro. With this flash bracket designed specifically for close-ups, the SB-25 can be positioned and aligned in a highly accurate manner.

position using the SC-17 adapter cable and TTL auto fill-flash mode. Also the Stroboframe LP Macro Flash Bracket is practical because it can be aligned with the SB-25 at exactly the right angle relative to the lens in the close-up range.

Modifying the flash brightness: By attaching the 20mm diffuser panel to the front the zoom head the flash intensity will be somewhat modified. If the flash still proves to be too bright in test exposures, it may be attenuated additionally by means of a neutral density filter or simple white typewriting paper.

Minimum aperture: Depending on the film sensitivity, Nikon recommends using a minimum aperture for flash distances less than 25 inches. If a larger aperture is selected, the TTL System may not have enough time to correctly adjust the flash.

Aperture (f/stop) number ≥ film sensitivity coefficient/shooting distance (m).

ISO	100 or less	125 - 400	500 or more
Coefficient (m)	(4)	(8)	(11)

Example of computation: For a distance of 25 cm between the flash reflector and the subject, an aperture of f/16 or smaller must be used with ISO 100!

Soft, shadow-free light using a light tent: Refer to "Tabletop Photography" for more information (p. 120).

Portraits

Lenses: Portraits require careful illumination and are best shot with focal lengths of approximately 80mm to 105mm. This focal length range is ideal because, even with a head-and-shoulders shot, a subject distance of approximately 5 to 10 feet can be maintained for flexibility in lighting and composition. In addition, portraits taken using this focal length range maintain a natural-looking perspective. Focal lengths less than 50mm often result in noticeable, unattractive distortion of facial features. Since a soft, out-of-focus background is usually preferred, a large aperture should be selected using aperture priority or manual mode. An additional advantage of the large aperture is that (due to the repro-duction gradient of the lens) the image usually becomes somewhat "softer" which often enhances appearance in a portrait.

Excessive contrast, partial over-exposure: Flash portraits which appear too contrasty or "washed out" can be prevented by using bounce flash with a diffuser card or by using the wide angle diffuser panel in front of the flash. In an emergency a piece of transparent paper which has been crunched and stuck to the flash head with tape will also work. This is not absolutely required for cameras with TTL auto fill-flash and the relatively "soft" SB-25 reflector but it may add a slight additional improvement. Bounce flash with the SB-25 using the built-in, flip-up diffuser card is also effective. With this, you can add "catch-lights" to the model's eyes, provided the distance is not too great.

Red-eye reduction with preflash: To guard against red-eye the preflash option should be used when shooting portraits. See also, "Red-eye" (p. 119).

Spatially Deep Subjects

Manual flash mode: You will quickly discover that very few subjects are flat; the vast majority have at least minimal depth. Imagine a long wedding banquet: If you select the aperture according to the center of the table, the bride in the foreground will be too bright, the groom at the other end will be too dark, while only the relatively unimportant center is properly exposed. Even bouncing the flash off the white ceiling in manual mode is a game of chance in this situation. To obtain the correct exposure would require bracketing. That, in turn, requires time that you probably don't have. Using TTL mode in this situation eliminates all of this hassle. When using this mode, as mentioned, the aperture is a function of the distance from the flash to the subject. But now what aperture to use?

TTL flash mode: Using this mode, the flash brightness on the subject will be metered (even with bounce flash) and properly exposed pictures will result, in particular using TTL multisensor flash.

Variation of the background brightness: Usually spatial depth "swallows up" light emitted by the flash. Depending on the combination of camera model and SB-25, this can be prevented in various ways. See the chapter, "Flash Methods for Special Applications."

Copy Photography

Copystands: A stable copystand is an absolute "must" for copy work. This assures that the film plane is exactly parallel to the plane of the original. (Adjust with a bubble level!)

Flash unit setup: This is best done with two equally powered flash units mounted at a 45 degree angle. Diffusers in front of the flash units are also recommended in this application. The distance from the lights for subjects up to 8 x 11 inches should be about one yard. If you do not own two SB-25 units, the second unit may be any less powerful, simpler flash unit. This should be used in

manual mode and the SB-25 can be matched to this unit by reducing the output level. The system is activated (see also, "TTL Multiple Flash Photography" p. 94) by using SC-17 and SC-19 cords or by using a slave unit to trigger the second flash.

Red-Eye
Cause and cures: Notorious red-eye can be blamed on the camera-mounted flash unit. If the flash axis and lens axis are almost the same, the light reflected off the red retina at the rear of the eye becomes visible. If there is a significant distance between the lens and flash axes, however, this red light is reflected out of the image area. Diffusing the flash is one solution, but it reduces the flash intensity. A better alternative is the use of a flash bracket, such as those manufactured by Stroboframe®. These brackets raise the flash high above the camera, effectively eliminating red-eye. Remember, that the preflash option is also available when using SB-25 with the N90/F90. This works fairly well, but most professionals rely on other methods in addition to preflash. See section, "Variable Stroboframe® Flash Brackets" (p. 34).

Preflash prevents squinting: The preflash also may be used with the N90/F90 camera and the SB-25 to prevent squinting. Although Nikon doesn't specifically recommend this technique, I have found it to be helpful with certain models.

Red-eye portrait special program mode with preflash: This is possible only with the combination of the N90/F90 and the SB-25 but not required.

Product Photography
Pictures of objects: No photographer should claim "artistic freedom" with product shots. Whatever needs to be shown must be visible! As a rule this calls for extremely sharp images, large depth of field, and uniform illumination. Therefore, studio-type pictures of objects require high flash output because the necessary image sharpness is best achieved by using low-sensitivity films and relatively small apertures.

Illumination: Uniform illumination is important because shadows and high contrast lighting will interfere with the finished result.

You should use shadows for artistic expression only when you have mastered proper illumination.

Using one SB-25 flash: A cleverly used, high-power flash unit like the SB-25 will frequently yield amazing results. For example, by using an umbrella, the flash may be transformed into a large-area, soft light source. An additional white or silver reflector (the Domke company makes some of the most versatile) can help lighten shadows.

Multiple flash units: You can work even more precisely with several flash units; having three in a studio will cover most any circumstance. Normally, the strongest flash is fired nearly straight-on as the main light source. Specialized diffuser panels, such as those made by Domke, do wonders with otherwise harsh lighting. A second, weaker unit can be used as background illumination or as a bottom light, and the third can be positioned to create accents. Since modeling lights are very useful but somewhat extravagant for a basic studio, two cheap clamp reflector sockets with 60W bulbs are an economical alternative
Helpful hint: Build a light tent out of tracing paper or diffusion material and use one flash unit on either side.

Sports and Action
Lenses and films: Generally, flash photography is strictly forbidden in sporting arenas. If you are in a situation where flash is permitted, use a telephoto lens (approximately 180mm to 400mm) and fast film. When using a flash, most cameras can accommodate films with film speeds of up to around ISO 1000. But even with fast films, it becomes rapidly obvious that the SB-25's output is sometimes inadequate at distances up to or exceeding100 feet. Unfortunately, Nikon does not include a light-intensifying telephoto attachment with the SB-25.

Tabletop Photography
Basically the principles are similar to those described earlier in photographing objects.

Light tents: One special way of creating uniform illumination when shooting smaller objects is to create a light tent of transparent

paper or diffusion material and to illuminate the subject with one or more flash units positioned at an appropriate distance. It is ideal to use one flash unit on each side of the tent as described in the section "Copy Photography." However, unlike copy work, TTL control may be used and the flash units do not have to be equal in output. In spite of the light tent (or more accurately because of it) the more powerful flash unit will only cast a weak shadow which will favorably enhance the three-dimensional appearance of the objects.

The Basics of Flash Technology

Thanks to autoflash anyone can take flash pictures without tedious computations. Nevertheless, most photographers will find knowledge of the fundamentals of using flash helpful. For example, did you know that an aperture of f/8 with a guide number of 32 will reach only a ridiculous 10 inches farther than the same aperture with a guide number of 30? Or do you know why the N90/F90's 3D-autoflash with the SB-25 produces better results than the F4 or N8008/F-801 in matrix-balanced autoflash mode?

Flash Output, Duration and Guide Number

Light energy is a product of flash output and duration: The degree of brightness of a subject illuminated by a flash unit is a function of the output (Watt) of the flash unit. The resulting photographic exposure is a function of the duration of this output. Therefore, the energy emitted by the flash (Ws or Joule) is calculated as a product of flash output and duration.

Brightness decreases with distance: Not only is the energy emitted by the flash unit important to the final exposure, but also the proportion of this energy arriving at the object to be illuminated. Therefore, the distance of the flash unit from the subject is of critical importance. Almost all light sources emit light at a specific angle, or cone of illumination. The area covered by this cone increases with increasing distance. This means that the same brightness will be distributed over an increasingly larger area. Effectively, because of this, an object will receive less light the farther it is located from the flash unit. Briefly, flash illumination is subject to the law that brightness decreases in proportion to the square of the distance.

Distance	1 m	2 m	3 m	4 m	6 m	9 m
Relative brightness	1/1	1/4	1/9	1/16	1/36	1/81

Guide number: Guide number is a value which takes into consideration flash energy, the relationship between brightness distance, and film sensitivity. It has been sensibly defined so that it only considers values which are important in practical applications, namely aperture and distance.

Guide number, aperture, and distance: If the distance from the subject has been predetermined and the guide number corresponding to the film sensitivity is known, the required aperture may be calculated quite easily. This answers the question, "What aperture should I select to obtain the correct exposure for a subject at a given distance?"

Aperture = guide number/distance.

Examples of computation: For example a flash unit with a guide number of 32 will properly expose a subject at a distance of 2 m with an aperture of 16 (32/2). At 4 m distance the aperture would have to be 8 (32/4). Conversely, if, for example, a subject at a distance of 8 m will be properly exposed with an aperture of 4, the correct aperture at distance at 2.9 m would be 11. Most flash units have a computation disk or slide which indicates the distance range at a given aperture, or the correct aperture for a given distance. (In manual mode, the SB-25's LCD will automatically indicate the appropriate distance for a preselected aperture.)

Guide number and film sensitivity: The guide number indication normally refers to a film sensitivity of ISO 100. More sensitive films use a higher guide number, hence the distance range increases at a given aperture. Each time the film sensitivity is doubled, the applicable guide number is multiplied by 1.4. (If the guide number was 40 with ISO 100, the guide number will be 56 with ISO 200). Therefore, if the distance from the subject is the same, you may reduce the aperture by one f/stop when the film sensitivity is doubled. This is also illustrated on the flash unit's display panel.

Guide number and zoom flash heads: With zoom flash heads the illumination angle is modified so that the angle of view of different focal lengths will be covered by the flash. This is accomplished

by adjusting the position of the flash head diffuser relative to the flash tube. By adjusting the zoom head, the flash energy is concentrated on a smaller angle of illumination, hence greater distance, or diffused over a larger angle, hence shorter distance. The following applies: The smaller the angle of illumination (long focal lengths), the greater the guide number; the greater the angle of illumination (short focal lengths), the smaller the guide number.

Guide number in autoflash mode: In automatic flash modes the guide number of the flash corresponds to the maximum energy output when the flash is fired without automatic system compensation. If the subject or the distance requires flash energy which is lower than this guide number, the energy or duration of the flash is reduced by the autoflash system. Therefore, the automatic system has saved us from having to make troublesome computations with guide numbers and apertures.

Guide number with multiple flash: When working with several flash units simultaneously, the combined guide number is important regardless of which flash mode is used. With similar direction of illumination and uniform distance from the subject, the combined guide number of the individual flash units can be determined by squaring and adding the individual guide numbers (GN), and by ratifying the sum:

Combined guide number $= \sqrt{(GN_1)^2 + (GN_2)^2 + ... (GN_n)^2}$

Aperture with a combination of several flash units: If several flash units are used at different distances, the appropriate lens aperture can be computed. It is the result of the combined action of each aperture setting (AP) for each individual flash unit.

Combined aperture $= \sqrt{(AP_1)^2 + (AP_2)^2 + ... (AP_n)^2}$

Different flash distances with autoflash mode: There is no simple formula for this. For best results with studio flash take a reading on the subject with a flash exposure meter and shoot test exposures. This way the effect of the individual flash units and their combined effect may be tested step-by-step.

Autoflash Modes

In order to appreciate the limitations and advantages of different autoflash modes, it is helpful to understand how they work.

Flash Output Control
Principle: If the autoflash system determines the distance from the subject and the selected aperture before firing, it will simply adjust its output accordingly before firing. A flash with a guide number of 40, an aperture of 8, and a distance from the subject of 4m would automatically be adjusted downward to a guide number of 32, and at 3m to a guide number of 24, etc. To my knowledge, complex electronic control of the actual flash output is presently not used by any camera/autoflash mode (instead it simply adjusts the duration of the flash). However, there are some studio-type flash systems which permit manual preselection of the flash output while the duration of the flash remains the same.

Confusing use of "flash output" and "flash intensity:" In its publications Nikon frequently uses the concepts of controlling or adjusting the "flash output" or "flash power," even though actually, "flash energy" is meant. In this book I have at times used this "simplified" language. To my knowledge, all Nikon SLR cameras and flash units control the flash energy via manual presetting or automatic control of the duration of the flash.

Autoflash with AF Distance Measurement
In autoflash mode the aperture and duration are computed from the guide number and the AF distance: The appropriate duration of the flash may be adjusted when the flash output and the exact distance from the main subject are known. (This is the same in fully manual flash mode.) The N90/F90's 3D autoflash mode (see below) utilizes the distance information provided by AF lenses. *Advantage:* Because this method is independent of the reflectance of the surroundings outside the picture, very precisely exposed pictures are obtained. *But also note the disadvantage:* Because the flash output is calibrated based on the <u>average</u> reflectance of the subject's surroundings outside the picture, exposure errors may occur. If the surroundings absorb more than the <u>average</u> amount of light, the main subject becomes too dark. If the

surroundings reflect more than the average amount of light, the main subject becomes too light.

An example, Medical Nikkor lens: Nikon has used this method for a long time with the Medical Nikkor lens: The manual focus adjustment is coupled by electromechanical means with the aperture and flash duration control. As a result, extremely accurate flash exposures are obtained in the critical close-up range.

Control of Flash Duration Based on Reflected Light
Non-TTL autoflash: The possible duration of a flash exposure ranges between approximately 1/200 sec. and 1/50000 sec. (1/1000 sec. and 1/23000 sec. for the SB-25). The principle behind non-TTL autoflash mode is the automatic control of the flash duration based on exposure conditions. Conventional autoflash units have a built-in external photosensor which measures the light reflected by the subject during the flash exposure. The flash control is totally independent of the camera (see below).

TTL flash control: In this mode the light from the flash reflected off the subject is measured by the camera (see below).

Non-TTL Automatic (sensor) Flash
A misleading concept: Sometimes improperly labeled, "computerized flash," this concept dates back to a time when every manufacturer who offered slightly nifty electronics integrated in flash units would identify them as having an internal "computer" for marketing purposes. Only the SB-24 and the SB-25 have integrated microprocessors and therefore are "genuine" computerized flash units.

Non-TTL automatic flash clearly defined: Non-TTL autoflash refers to flash duration control via the sensor in the flash unit. This is independent of the camera. On Nikon flash units, including the SB-25, this function is identified by "A."

Operation: Let's look at a typical automatic flash unit which has a guide number of 40 at full power and at a duration of 1/1000 sec. (an aperture of f/8 and a range of 17 ft.). If, after releasing and firing the flash, too much light is reflected because the main subject

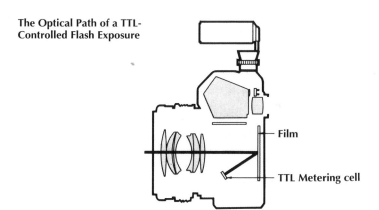

The Optical Path of a TTL-Controlled Flash Exposure

Film

TTL Metering cell

was at a distance of only approximately 10 ft., the sensor will automatically switch off the flash and reduce the flash duration to 1/2000 second. This results in a well-exposed picture. The main drawback of non-TTL autoflash is that the angle covered by the flash's sensor frequently does not coincide with the image angle of the lens. The sensor located on the flash unit has a fixed measuring angle of approximately 60°. This angle approximates the field of view of a 50mm lens. The use of wide angle lenses with a larger angle of view and telephoto lenses with a considerably narrower image angle may easily result in incorrect flash exposures because of this. Either too little light reflected by the subject may be detected or light reflected from areas not even in the final picture may register. In addition, most non-TTL automatic flash units work with a rather restricted aperture range.

Standard TTL Flash
Principle of TTL flash metering: In TTL autoflash mode the flash exposure is measured through-the-lens (TTL). The mirror is flipped up, the aperture closes down to the correct value, the shutter opens fully, and then the flash is fired. During the period when the shutter is open, the flash metering cell on the camera bottom measures the light reflected off the film and regulates the flash duration accordingly.

Built-in consideration of angle of view and aperture: Compared with conventional non-TTL automatic flash units, TTL flash control

has the advantage that it covers the image angle of the lens accurately. Also lens converters or filters are automatically taken into consideration. In TTL flash mode the aperture set on the lens is of relatively little consequence because a wide range of different apertures are automatically compensated for by adjusting the flash duration.

Limitations of TTL Flash

Electronic limitations: As with any type of electronic instrument control, TTL flash has its limitations. First of all, a certain (albeit short) time is required for the camera's electronics to measure, compute, and send the thyristor of the flash unit the "deactivate" signal (these thyristors act as electronic power switches). Also, a thyristor has an intrinsic switching time. If the actual required flash duration is shorter than this computing and switching time, over-exposed images will result. Whenever (using the guide number of the flash unit and the film speed) the distance from the subject is very small and the aperture is very large, TTL-controlled flash exposures could possibly be overexposed.

Limits of standard TTL autoflash: Whenever (for example, with flash exposures in total darkness or with fill-flash) the main subject does not fill the picture and is not at a uniform distance, only a fraction of the flash light will be reflected by the subject. The remainder of the light emitted by the flash is lost in the background "next to" the main subject. The TTL autoflash attempts to overcome this by prolonging the duration of the flash. The result is over-exposed main subjects, especially, when they are in the foreground.

Limits of standard TTL auto fill-flash: When there is a noticeable amount of ambient light or the subject is definitely backlit, for natural-looking results, existing light and/or background brightness must be exposed with an appropriate combination of shutter speed and aperture. This does not occur automatically with conventional TTL auto fill-flash.

Manual exposure adjustment and flash compensation: On N8008/F-801, F4, and N90/F90 cameras manual flash corrections may be made via the SB-25's manual flash compensation function.)

In manual exposure mode the aperture and, depending on the camera model, the shutter speed may be adjusted to the brightness of the ambient light and background.

Unusual reflectance of the subject: Problems arise with subjects exhibiting unusual reflecting power or the lack of it. Autoflash is calibrated (as are most exposure meters) for a subject with medium reflecting power. This calibration to so-called, "18%, or medium gray" may have a negative effect on flash metering and control. Naturally dark subjects with low reflecting power will be lightened automatically and reproduced in an unnaturally light manner. Conversely, very light subjects with high reflecting power will be photographed in an unnaturally gray or dark manner. The bride in white in front of the white wall will be too dark, the black cat in front of the black car will be too light. If you want to do better than the autoflash exposure, you must set the flash unit and the camera to manual mode. If the subject reflects light in a highly irregular manner, you should not rely on automatic flash. Ultimate perfection is possible only using fully manual flash and metering by hand. Only the N90/F90's autoflash with TTL multisensor, monitor preflash, and 3D matrix control in combination with the SB-25 will be able to cope with many of these problem subjects automatically.

Simple TTL Auto Fill-Flash
Definition: This automatic feature makes an automatic preflash correction but does not sufficiently consider continuous light or background brightness when determining the aperture and shutter speed (compared with matrix-balanced TTL auto fill-flash).

Exposure metering in TTL flash affects only ambient light: The automatic flash features of all current Nikon cameras work with a selected camera exposure metering method ("matrix," "center-weighted" or "spot"). This selection effects only the measurement of ambient light. TTL flash control is completely independent and always has a slightly center-weighted bias (with the exception of the N90/F90's five-field TTL multisensor flash metering). Some Nikon cameras with auto fill-flash also have an automatic minus correction of the flash exposure when set for spot or center-weighted ambient light metering. This automatically counteracts too much flash exposure of the foreground.

Center-weighted TTL auto fill-flash: This slightly confusing description causes one to assume that the flash is metered in a center-weighted manner before the camera is fired in order to determine the shutter speed and the aperture appropriate for the level of ambient light. In automatic exposure modes such as aperture priority, shutter priority, or program usually the main subject in the foreground is over-evaluated for ambient light while the background remains under-evaluated. Therefore, as a rule, auto fill-flash with automatic program or aperture mode often results in an unnaturally light background. Center-weighted ambient light metering should therefore be used only with older cameras that do not feature matrix metering or when an AF lens is not available for modern AF cameras. The best procedure in this case is center-weighted TTL auto fill-flash with manual adjustment for the background (see below).

Spot Metering: The same reservations apply as with center-weighted metering, in many cases this is even more critical.

Targeted adaptation of the background: Using TTL auto fill-flash and manual camera exposure adjustment, a targeted adaptation of the background by spot or center-weighted metering permits a precise adjustment of the brightness of the foreground and the background. The minus correction of TTL auto fill-flash creates a subtle lightening of the foreground.

Matrix metering: Only matrix metering automatically considers surrounding light and subject contrast (see below).

Matrix-Balanced Fill-Flash
Definition of "matrix:" The term "matrix" often causes confusion. It applies to a multi-pattern evaluation of the brightness and contrast in a scene. This process then provides exposure information to the camera's multiprocessor. Matrix metering will analyze the brightness in a scene and refer the "light pattern" that it sees to a stored memory of thousands of potential light patterns and select an exposure "intelligently" from that evaluation. In comparison, center weighted or spot metering simply calculates an exposure value to reproduce a metered area as 18% gray. In any case, the camera can automatically select aperture and/or

shutter speed as needed, based on the exposure mode ("P," "S," or "A"). If the camera is in TTL fill-flash mode the flash exposure will be reduced somewhat during the exposure for a more natural-looking result. This is based on a reference value provided by the camera's TTL flash sensor. If in matrix metering the camera may choose flash reduction over a controlled range to match the brightness and contrast characteristics of the original scene. Since matrix is an "intelligent" meter it can provide the information the microprocessor needs to choose the flash exposure compensation. More accurately, matrix influences flash exposure, but does not, strictly speaking, control it.

Exposure metering and flash compensation before the flash exposure with TTL control during it: In this mode, with the N6006/F-601, N8008/ F-801, and F4 cameras, the camera's computer links the automatic features of the ambient light exposure mode with the methods of TTL-controlled flash metering. In practice this means that in autoflash mode and matrix metering both background light and subject contrast are taken into consideration. Along with this exposure metering, the autoflash preselects the aperture and/or the shutter speed before the flash is fired, and then adjusts the duration of the flash based on the light reflected off the film during the TTL flash exposure. This type of autoflash may be activated in all exposure modes with automatic aperture or shutter priority and program modes as well as manual exposure mode. However, matrix-balanced flash mode is most effective only with automatic program mode because the full range of shutter speeds and apertures is accessible automatically.

Matrix control of various situations: Depending on total brightness and contrast, matrix-balanced autoflash evaluates the existing light and preselects aperture, shutter speed, and flash duration. A distinction may be made among the following borderline cases of automatic exposure and flash control:

❐ *Extremely dark, any contrast:* The camera's computer automatically sets the aperture and shutter speed appropriate for the brightness measured in the central segment. At the same time the computer makes a definite minus correction in order to prevent overexposure.

❏ *Moderately dark, any contrast:* The camera's computer automatically sets the aperture and shutter speed appropriate for the darkest image area. At the same time the computer makes a definite minus correction in order to prevent the foreground from becoming too light.

❏ *"Normal" dark, any contrast:* The camera's computer automatically sets the aperture and shutter speed appropriate for the average image brightness. At the same time the computer makes a definite minus correction in order to prevent the foreground from becoming too light.

❏ *"Normal" light, low contrast:* The camera's computer automatically sets the aperture and shutter speed appropriate for the lightest image area. At the same time the computer makes a definite minus correction in order to prevent the foreground from becoming too light.

❏ *"Normal" light, medium to low contrast:* The camera's computer automatically sets the aperture and shutter speed appropriate for the lighter image areas. At the same time the computer makes moderate to significant minus corrections to the flash.

❏ *"Normal" light, high contrast:* The camera's computer automatically sets the aperture and shutter speed appropriate for the lightest image area. At the same time the computer makes a slight minus correction to the flash because there is only a slight chance that the foreground will be unnaturally light.

White or black main subject: These exposures were taken with the N90/F90 and an AF-D Nikkor lens in 3D-TTL multisensor auto fill-flash mode. Without exposure compensation the white subject appears too gray. Depending on the desired brightness, an aperture adjustment of approximately +1.3 to + 2 f/stops should be made. The black subject is even trickier because it is highly reflective. The 3D autoflash feature actually handles this quite well; with zero adjustment the black gloves are only a bit too gray and appear quite natural with -0.7 compensation. Depending on the desired rendition, a less shiny subject could tolerate a somewhat greater minus correction. Conventional TTL autoflash would require even more significant compensation.

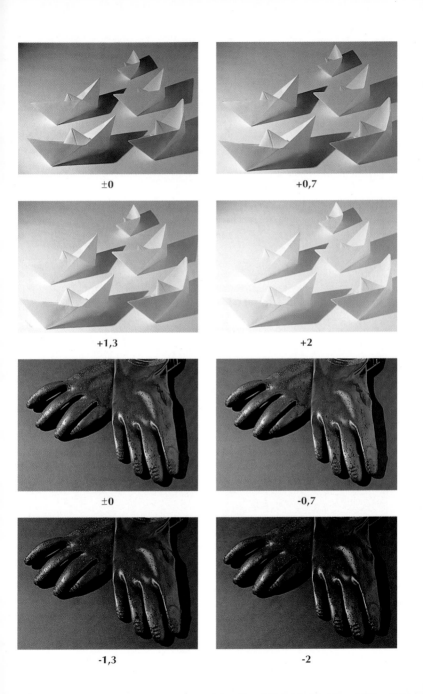

±0

+0,7

+1,3

+2

±0

-0,7

-1,3

-2

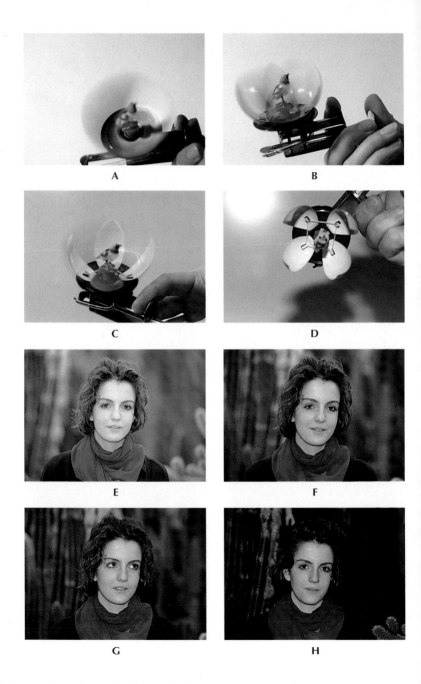

In each of these cases the flash duration is further controlled based on the light reflected by the surface of the film while the shutter is open.

From Normal Flash to Fill-Flash

Flash exposures in total darkness: Traditionally, TTL autoflash is based on the determination of a guide number corresponding to the aperture and/or the flash duration, and the distance. In total darkness this may still be true to some extent. However, "normal" flash pictures usually look like typical "flash" pictures. A better balance with the foreground is attained only by making minus corrections to the flash duration and plus corrections to the background.

Existing light fill-flash exposures: If there is noticeable existing light (e.g., outdoors at dusk or incandescent light in a room), pictures taken with conventional autoflash will appear unnaturally overexposed. Only a minus correction of the flash duration and an aperture opening appropriate for the existing light, as well as a relatively high shutter speed, will provide "atmosphere."

Backlit fill-flash exposures: In this case the aperture and shutter speed must be adjusted for the background brightness. Flash compensation for the foreground will provide natural-looking pictures.

Freezing motion with high-speed sync "FP:" High-speed synchronization permits flash exposures with extremely short shutter speeds of up to 1/4000 sec. (A) was exposed at f/4 at 1/60 sec. without flash. As you can see, the movement was blurred. (B) was exposed at f/4 and synchronized normally at 1/60 sec., TTL fill-flash was used, and an out-of-focus ambient light image was superimposed on the sharp flash image. (C) was exposed manually at f/5.6 with FP synchronization for 1/2000 sec.; there are still a few visible traces of movement. (D) was exposed at f/4 with FP-synchronization at 1/4000 sec. This has frozen the motion completely.

Effect of total exposure compensation in TTL flash mode: This series of exposures was taken in matrix-balanced programmed TTL auto fill-flash with aperture adjustments of +1.5, +0.7, 0.0, and -1.5 (E, F, G, H). Because aperture changes affect the exposure of both ambient light and flash, the brightness of the foreground and background were uniformly changed.

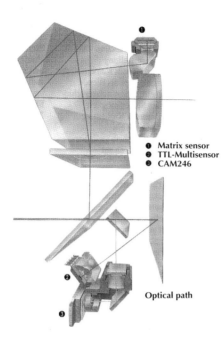

Optical Paths of Different Systems for Determining Sharpness and Exposure (N90/F90).

❶ Matrix sensor
❷ TTL-Multisensor
❸ CAM246

Optical path

1. Shutter curtain
2. Bottom of the mirror box
3. Condenser lenses
4. TTL Multisensor

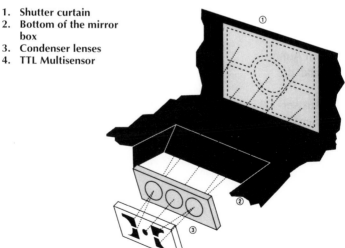

Multisensor Flash Metering in the N90/F90.

Autoflash with Monitor Preflash: with N90/F90 and SB-25.

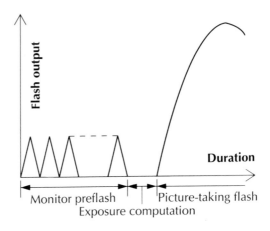

Monitor preflash | Picture-taking flash
Exposure computation

Smooth transition of matrix control: In contrast to standard TTL flash control, matrix balance in flash mode will automatically weigh all existing conditions.

TTL Multi-Sensor Auto Fill-Flash
Presently this method can be used only with an N90/F90 camera with an AF Nikkor lens and any TTL flash unit. Normal matrix control, utilizing a preset aperture and/or shutter speed and an automatic preliminary compensation of the flash duration occurs preliminarily. After firing the flash, TTL control takes effect based on five-field multisensor metering. Because the N90/F90's computer considers those segments which report unusually intense or unusually low light, the multisensor corrects extreme reflectance particularly well. Therefore, in multisensor autoflash mode a "subject-specific" fine correction of the flash during the actual exposure occurs in addition to the "subject-specific" preselection of aperture, shutter speed, and flash duration.

Multi-Sensor Control with Monitor Preflash
When the SB-25 is used in conjunction with the N90/F90 camera, the flash unit emits a series of invisible preflashes which are evaluated by the multisensor before the shutter release is depressed fully. As a result of this, information on the spatial distribution and the reflectance of the main subject and the background is relayed to the autoflash system. The computer will then perform subject-

specific preliminary compensation of the flash duration in addition to the matrix meter information if necessary.

3D-Matrix Control

When using type D-AF Nikkor lenses, the N90/F90's autoflash system will consider the distance from the main subject and the sharpness of the center of the picture at the time the shutter is released. This is done roughly in the following steps:

- ❏ **Conventional matrix metering:** The computer adjusts aperture, shutter speed, and preliminary flash compensation according to matrix metering prior to firing.

- ❏ **Comparison with a theoretical flash adjustment value based on the distance measurement:** The computer compares a previously determined flash exposure value (derived from guide number, aperture, and preliminary flash correction) with a theoretical value resulting from the distance and, if necessary, readjusts the preset flash exposure.

- ❏ **Focus check for off-center subjects:** At the time of firing the computer will recognize if the center of the image is out of focus, if the image section has changed, and/or if the main subject is no longer in the center. In these cases the computer sends the command to the TTL multisensor to reduce the emphasis of the measured central field during the actual flash exposure.

- ❏ **Monitor preflash for final, fine preliminary correction of the flash:** These measuring flashes (with SB-25 only) determine extreme reflectance conditions in the surrounding areas and result in an additional fine-tuning of the flash "output." The computer will then determine the weighting of multisensor metering while the flash is being fired.

- ❏ **TTL multisensor control during exposure:** The last fine compensation and final determination of the flash duration takes place by the five-field multisensor during the actual flash exposure.

Flash Synchronization

Definition of flash synchronization: For complete exposure of the film frame, the flash must be fired when the focal-plane shutter is fully opened across the entire width of the image. In the case of the N90/F90 this occurs at shutter speeds of 1/250 sec. or longer. If the flash is fired before the shutter is fully opened (at speeds faster than 1/250 sec.) partial, striped or even completely unexposed pictures will result. As a rule, this is not a problem with modern Nikon cameras because the camera will not select a shutter speed faster than the maximum available sync speed in any of the automatic modes (except with the N90/F90 and SB-25 on "FP").

Slow-synchronization: It used to be that flash release was superfluous with slower shutter speeds. This frequently caused double exposures due to the short-term flash and the additional long-term ambient light exposure. Any movement resulted in a blurred image superimposed on the sharp flash image. Most times this is unappealing, and only occasionally "artistic." However, it is possible to place a non-moving main subject exposed with flash in front of a properly exposed existing light background if the shutter speed is selected carefully (at normal shutter speeds this would be a black background). This is why some newer cameras such as, the N6006/F-601 and the N90/F90 feature an automatic "SLOW" function which allows the use of shutter speeds up to 30 sec. in all automatic flash modes. Other cameras permit the preselection of slower shutter speeds by combining TTL auto fill-flash with manual exposure adjustment.

First and second shutter curtain sync: With the fastest flash synchronization speed of 1/250 sec. it makes no difference whether the flash is fired precisely after the complete opening of the first shutter curtain or "only" when the second curtain begins to move. The firing point is the same, namely, when the first shutter curtain has stopped and the second one has started. With slower shutter speeds, however, synchronization with the first curtain causes the exposure by existing light to occur <u>after</u> the flash is fired. With second shutter curtain ("REAR") sync, however, the existing light exposure takes place <u>before</u> the flash is fired. The difference can be seen when photographing moving objects; they

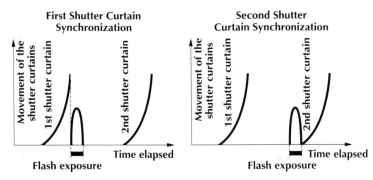

First Shutter Curtain Synchronization

Second Shutter Curtain Synchronization

Graphic Representation of First and Second Shutter Curtain Sync

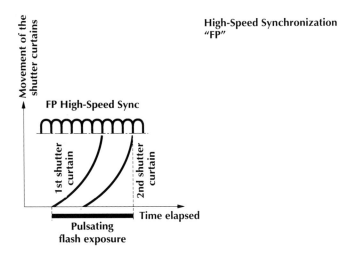

High-Speed Synchronization "FP"

FP High-Speed Sync

will have natural-looking motion blurs only in "REAR" mode. The SB-25 can be synchronized with the second shutter curtain when used with most modern Nikon cameras.

High-speed synchronization "FP:" Currently, this feature is available only with the N90/F90 and the SB-25. With normal brightness, extremely fast shutter speeds combined with fill-flash completely "freeze" a moving object. Extremely fast synchronization speeds may also be used with fill-flash by using large apertures to offset a flash-exposed backlit subject in front of a

normally bright, blurred background. This would not be possible in normal automatic fill-flash mode because normal shutter speeds would make the background far too light. For these situations the N90/F90 offers high-speed synchronization "FP" at up to 1/4000 sec. in manual mode in combination with the SB-25.

Procedure for high-speed flash "FP:" With conventional flash synchronization, a single flash is fired shortly after the first or second curtain has opened. In "FP" mode, the opening of the first shutter curtain causes the SB-25 to trigger an uninterrupted sequence of short high-frequency flash pulses. While the slotted opening of the shutter curtains sweeps over the film, the subject receives continuous flash exposure. This action distributes the total flash output over many flashes which do not expose the entire image but only the respective shutter strip. This decreases the effective flash output, causing the guide number to also drop significantly. TTL flash control is not possible with "FP;" the camera and flash must be adjusted manually.

Notes

Notes

Notes

Notes

Notes

Notes

Notes

Notes

Notes